TUAN ANDREW
NGUYEN

TUAN ANDREW NGUYEN

Radiant Remembrance

Edited by Vivian Crockett and Ian Wallace

NEW MUSEUM

Contents

Foreword

—

Lisa Phillips

Since the early 2000s, Tuan Andrew Nguyen has developed a body of work that blurs fact and fiction to highlight under-examined and suppressed histories and to explore the possibility of global decolonial solidarity. Through collaborative community engagement and extensive archival research—often brought together with mythologies of otherworldly realms—Nguyen reworks dominant narratives into stories that propose creative forms of healing the intergenerational traumas of colonialism, war, and displacement.

Drawing together conceptual threads from across the Global South, Nguyen's exhibition at the New Museum sparks a dialogue around inherited memory and testimony as forms of resistance and empowerment. "Tuan Andrew Nguyen: Radiant Remembrance" is the artist's first US solo museum presentation. We are proud to provide the first opportunity for US audiences to see this deeply researched, significant body of work in a unified exhibition that showcases a new film, *Because No One Living Will Listen* (2023), and two recent video projects, *The Unburied Sounds of a Troubled Horizon* (2022) and *The Specter of Ancestors Becoming* (2019), alongside works from the artist's broader practice. This publication contextualizes the pieces presented at the New Museum among a number of additional examples of Nguyen's works in sculpture, demonstrating the full breadth of his richly imagined practice.

As part of the fake advertising company-cum-art-collective The Propeller Group, which he cofounded in 2006, Nguyen was included in the 2012 New Museum Triennial, "The Ungovernables." Like the Triennial, this solo exhibition demonstrates the Museum's long-standing commitment to debuting the work of some of the most exciting, forward-thinking artists from around the world.

I would like to thank the curator of the exhibition, Vivian Crockett, Curator, for her work in bringing this poignant show to the New Museum, along with Ian Wallace, Curatorial Assistant, who contributed to every aspect of the exhibition and this publication. I would also like to thank David Hollely, Director of Exhibitions Management, and his entire team for their work in realizing the

installation: in particular, Abby Lepold, Senior Registrar; Carlos Yepes, Registrar; Patrick Foran, Chief Preparator; Olivia Biggs, Production Preparator; and Telo Hoy, AV Preparator. I would also like to thank Isolde Brielmaier, Deputy Director; Diane Vivona, Vice President, Advancement; Mariah Mazur, Director of Development; Dennis Szakacs, Chief Operating Officer; and their respective teams for their support in making this exhibition possible.

This catalogue is the result of Sarah Stephenson's fastidious editing and Nicholas Weltyk's thoughtful design. It includes new texts providing insightful, nuanced considerations of Nguyen's work by Zoe Butt, Catherine Quan Damman, Eungie Joo, and Christopher Myers, a poem by the artist's grandmother, Nghiêm Phái-Thư Linh, as well as an interview between Crockett and the artist. Fatima Sy and RAW Material Company, Dakar, were instrumental in coordinating with the Vietnamese-Senegalese families who generously allowed for the reproduction of photographs from their personal archives.

This exhibition would not have been possible without the support of Nguyen's gallery, James Cohan, New York. In particular, I would like to acknowledge Paula Naughton, Sarah Stengel, and Sascha Feldman.

I am deeply grateful to our Board of Trustees and generous sponsors for their support of "Radiant Remembrance." Support for this exhibition is provided by the Toby Devan Lewis Emerging Artists Exhibition Fund. Artist commissions are generously supported by the Neeson/Edlis Artist Commissions Fund. Generous support is provided by The Vega Foundation. We gratefully acknowledge the International Leadership Council of the New Museum. Thanks to James Cohan, New York. Education and community programs are supported, in part, by the American Chai Trust. Support for the publication has been provided by the Carl & Marilynn Thoma Foundation and the J. McSweeney and G. Mills Publications Fund at the New Museum.

Finally, I would like to thank Tuan Andrew Nguyen for his careful stewardship of such profound and underrepresented stories.

—Lisa Phillips, *Toby Devan Lewis Director*, New Museum

Speaking with Ghosts

—

Vivian Crockett
in Conversation with
Tuan Andrew Nguyen

Vivian Crockett: I'd like to start with the ideas of collectivity and collaboration and how they have been central to your work from the beginning. Even as you are an "individualized artist" now, you work a lot with bringing others into the fold—and we were just talking about giving people space and agency and navigating what that looks like. Could we dial it all the way back to the early projects you embarked on and cofounded, like The Propeller Group and Sàn Art, and how you feel they've shaped your work now?

Tuan Andrew Nguyen: I would rewind it even further. The idea of collectivity was built into my process since the beginning of my art education. I was totally new to contemporary art when I switched majors in undergrad—from biology to fine art—and I was very fortunate to meet a group of friends who were nurturing and generous in how they shared their knowledge of art with me. I was completely lost. We had a mentor, Daniel Joseph Martinez, who took us all under his wing—he was super generous, volunteering his time outside of working hours. We had a critique class with him—there were about seven or eight of us—and he started calling us the Renegade Artists, as a fun, endearing term. And we started making projects together.

That's when I really started to soak up this idea of collaboration—Daniel had also been in multiple collectives within his own practice. When I was at CalArts, I got a chance to work with a collective called SUPERFLEX, who were visiting artists. I went to Brazil with them to help them shoot their Guaraná Power advertising project in the Amazon. It was a really rich experience, learning hands-on how a group worked together and could then work with another group—farmers, who were collectivizing and protecting their resources against the big beverage companies trying to come in and co-opt a lot of what they were doing.

VC: It's interesting to think about SUPERFLEX shooting a Guaraná commercial by appropriating the tactics of beverage conglomerates to empower local farmers and push back against corporate interest. Was that part of the seed for you and also for The Propeller Group? Was this an early example of how to reclaim this framework of advertising?

TAN: I never linked it back to that SUPERFLEX project—that's a keen observation. I'm sure that had much to do with my desire to work with communities, how I came to think about working collectively, and how that could extend into working in public via advertising. I also grew up in Southern California in the '90s and was really into hip-hop, and I was b-boying and doing a lot of graffiti. Graffiti was this strange mixture of working as an individual artist while simultaneously representing a collective—everybody was part of a crew.

VC: Talk about transnational solidarity and South-South connections! Each of those creative realms was a space for transcultural exchange to happen organically.

TAN: It's actually a kind of embodied knowledge. We might travel to Florida for a dance competition and see a Brazilian b-girl or b-boy, and then take their move back to California. You embody it, and then someone else takes your version of it and does the same thing.

VC: There's a part of me that gravitates toward artists who have navigated the diasporic reality of coexisting in the US while also having another place of origin. It's a particular experience of the world— you're from both and not from either. Reading some of the interviews you've given and learning about your experience of going back to Vietnam after art school also resonated with me.

TAN: When we first met, our conversation flowed beautifully because of that shared sense of being from here and not from here, being liminal. Diasporic people never feel grounded, and sometimes that's a great thing. When you're young, the youth—especially in some parts of the US—have a way of reminding you all the time that you're not grounded, not from "here." But as you get older, that ability to move about is quite inspiring. When I moved back to Vietnam, it was very much out of necessity to try to ground myself there through friendships, different working relationships, collaborations, collectives, and spaces.

The Propeller Group was a response to trying to make a documentary film about the first generation of graffiti artists in Vietnam. It was the early 2000s, and the trade embargo on Vietnam was lifted in 1994. But the media was very much controlled there. On my first trips back, going through customs, they would check the photos in my backpack to make sure they didn't represent the country in a bad way. When we were filming that documentary, all of our frustrations resulted in a desire to collectivize and work inside the system in a smart way, using the context that had arisen after the embargo lifted. There was a lot of favoritism toward advertising companies, and we discovered that registering as one gave us the most freedom to work in public. So The Propeller Group was born.

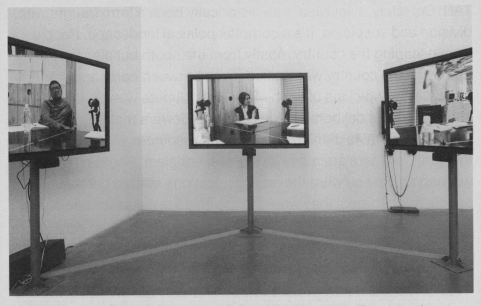

The Propeller Group, *Television Commercial for Communism*, 2011. Five-channel synchronized video installation and LED monitor, color, sound; 5:45 hr (loop). Installation view: "2012 New Museum Triennial: The Ungovernables," New Museum, New York, February 15–April 22, 2012

Around the same time, 2007, Dinh Q. Lê and I were throwing around the idea of creating an alternative art space in Saigon. It was Dinh, Tiffany Chung, and myself, and I pulled in Phunam, who I had worked with on the graffiti documentary. The four of us founded and ran Sàn Art for a while. Then we invited Zoe Butt to join us, and she

took it to a whole other level. For me, it was about connecting with the local arts community—even though all four of us were marked as VK [Viet Kieu] artists, as Vietnamese returnees. We had to be considerate in regard to how we ran the space and interacted and connected with the arts community, not only in Vietnam but also abroad. Our goal was to create bridges between the different art communities.

VC: It feels like some degree of trust needed to be built with the local arts community, especially since you had access to different resources than local folks. It's not malignant, but there's a hint of suspicion there or even mistrust.

TAN: Definitely. "Viet Kieu" has historically been a term fraught with division and suspicion. It's a complex political landscape. People were escaping the country mostly from the south but also the north, and when the country was unified, even between north and south, there were suspicions of each other. This climate was produced and sometimes deliberately fueled by the powers that be. Southern Vietnamese artists didn't have the same resources as those from the north, so there are many layers of skepticism. Another thing working against us were the art organizations started before us by people from abroad: they would come in, do projects for one or two years, everybody would get excited, and then they would leave. After a few instances like that, it was hard for a local arts community to feel like they could invest their time, energy, and loyalty or friendship into another artist-run space like Sàn Art. One of the discussions we had early on was about maintaining the space and these relationships over an extended period. Longevity was a really important element, which also had to do with trust.

VC: I read your recent interview with Lumi Tan, and I really liked the way you spoke about what defines research. You've articulated that research is also about absorbing information, being open, attuned, present, and willing to listen. You also note that listening takes place over time, sometimes even when you don't realize that knowledge is being transmitted.

I think especially of *The Island* (2017; p. 93–99)—a project in the making from the time of your childhood based on you hearing stories about Pulau Bidong—and the knowledge that's embedded in our bodies. When you finally visited, you had this feeling of having already been there, which became a roadmap for the work you ended up producing at the site. You have a lot of projects still coming to fruition, which will have their moment to fully manifest, but in many ways, they've been developing over a long period.

TAN: I'm a really good listener. I was such a quiet child—you could almost forget I was there, but I would just listen to people talk and be mesmerized by their stories. I was never a good storyteller because I was super shy, but I would listen. Somehow, these stories that were really impressed upon me as a child have manifested themselves in projects over the last several years. There are a lot of strange subconscious mechanisms at play here.

A big part of my extended family ended up in Martinique, in the Caribbean. We would talk about Martinique all the time, and my cousins would come over and speak French, and then my other cousins would have children, and they'd be half Martinican, half Black, half Vietnamese. I never really questioned why they were in Martinique, why my cousins spoke French, and why we spoke English with a Southern drawl. It was just part of what was happening. It wasn't until much later, when I was in college and started to map the histories that brought us to where we were, that I started to realize how much history and the trajectories of colonialism and war affected who we came to be and where we ended up living.

VC: For some people, research is the archive and looking through old footage or historical records. Your work is embedded with factual, historical elements. But so much of your research is rooted in the intergenerational, the interpersonal, and in kinship networks, and it traces history through the unofficial record. You often evoke counter-memory—what we *actually* recall, which isn't how things are historically remembered.

TAN: I would go out on a limb and say that the archive is quite use-less—I'm speaking of official archival material. We put so much faith and hope in the archive that we tend to forget it has been recorded through the perspective of the dominant body. Much of the archival material has no names or captions—they were never really concerned about who they were photographing and what the people in the photographs were doing. I use the archive as a counterpoint to what I'm doing, creating a counternarrative and working with people that are marginalized or have been disregarded in the dominant narrative to bring their stories to the forefront. I'm obsessed with how that dominant perspective circulated and was reified, how it acquired and produced images, how it consumed and "produced" the other. I'm trying to think about how to undo that through the specific, personal stories of the people I work with.

VC: I appreciate that you appropriate it. You bring it into the work, so the archive's function is demoted. If anything, it reads as the fictive element of the piece. The other story—however speculative it may be—is rooted more in a sense of reality than the so-called "official" record.

TAN: It's interesting that it gets flipped a little bit.

VC: You've described codeveloping and cowriting dialogue in many of your works. How does that take place? In *Crimes of Solidarity* (2020; p. 119–25), for example, technology played a big role in developing the script. We are sometimes more accustomed to oversharing via the phone, while in person, being intimate can occasionally be more challenging—especially if you're navigating language barriers. These projects also sometimes happen in fairly quick timelines. I assume some of the collaboration process starts to flow from looking at old photographs or, in the case of *The Specter of Ancestors Becoming* (2019; p. 129–61), finding a letter, which becomes a seed for developing a dialogue that wasn't able to happen in real time.

TAN: I've taken multiple approaches, depending on the context, the community, the individuals within that community, and the time

period in which the project is happening. For *Crimes of Solidarity*, there was a sense of urgency because the inhabitants of Squat Saint-Just [in Marseille] were being threatened by eviction. The pandemic was happening at the same time, and many of my collaborators weren't comfortable with writing in the ways that, for example, my collaborators in Dakar were, so a lot of the writing happened through conversation.

It can be daunting for people who aren't experienced with the process of making moving images, so we have to be thoughtful in that process. Habiba, the woman we're working with on the Morocco-Vietnam project [*Because No One Living Will Listen* (2023)], never met her father—he died when she was two years old. So in our conversations, the idea of finding ways to speak to him came up, and now she's written a letter that we are basing the short film on. There are things like film or narrative structure that people aren't quite familiar with but would make the letter more accessible and intriguing for viewers. We don't want to lose viewers; we want to be generous and give them enough context to understand the story. And we share what we know about making moving images in a way that's sensitive to the sensibilities of the collaborator. It's a soft, fragile balance.

VC: *Crimes of Solidarity* is such an interesting example, especially as a record of the event. I find it striking to see the collaborators see themselves, especially in retelling traumatic experiences. There are moments when people avert their gaze, or they look up, but you see them fighting back sadness, or different emotions register on their faces. There's a meta quality that acknowledges the vulnerability of putting your story in a film.

A device you've used several times that I find powerful is ventriloquism—what it means to destabilize the text or narrative through this technique of saying and re-saying. There's a disembodied and then a re-embodied voice that comes into play, and there are the mistakes or slippages of trying to recreate the speech of someone else, or even one's own. There are instances in *Specter* where the

person narrating is also the one enacting, which does something to how narrative unfolds because it's not stable.

TAN: I was trying to trace back where that intuition to create these slippages comes from. I remember growing up watching kung fu flicks where the Asian characters were dubbed in English, especially in the Bruce Lee films, but they weren't totally in sync, simply because they couldn't be. It was such a surreal experience, so unfamiliar at first. Then, after a while, it became familiar.

When I went to Vietnam in the late '90s, my cousins invited me to watch a film in the cinema. Back then, there were maybe only three cinemas in Ho Chi Minh City, mostly playing Vietnamese government films—any foreign films were probably Russian. I can't remember what we watched because I was so mesmerized by the experience. While we looked at the image, two people in the back with microphones were live-dubbing all the characters—they would dub five or six showings a day. That probably informed or affected something in my mind about this idea of ventriloquism, about image, sound, and who's really doing the talking, how subjectivities could be transposed, and the misdirection when one transfers one's voice. It's like magic.

VC: In Brazil, we watched dubbed movies on TV, and it was always the same people doing the dubbing—the same dude for Harrison Ford and Mel Gibson. It was always the voice of the same woman or child actor, no matter what ethnicity the character was. I really wanted to be an actress when I was little, and I thought my entry point was going to be dubbing in movies.

There's something powerful in the way people in the act of ventriloquism are reclaiming, as you've described, our need to represent ourselves in legible, exaggerated, or dramatized ways in order to access safety and asylum. This comes up in *Crimes of Solidarity* or even in *The Island*, where the last two people on earth are rehearsing an immigration interview. I love that scene and its subtle humor. It's a way of upending the need for legibility in an interesting way.

I also appreciate that you work with people who aren't actors or, in the traditional sense, don't identify as actors. I'm curious to hear about the decision to work with "untrained actors," like Lai playing himself, but not—he's playing a version of himself on film.

TAN: I've only used a trained actor once—in *The Unburied Sounds of a Troubled Horizon* (2022; p. 191–225), the lead character had started doing television. And then my lead in *The Island* is a singer. He was invited to do a film before *The Island*, but he's not formally trained. I don't think of my process as working with "actors." When I'm making a new moving image project in collaboration with a group of people, in our team discussions, the term "actor" doesn't even really come up. They're more like agents—they have agency because they're writers as well; they're wholeheartedly collaborators. They are empowered to tell their own story, and I'm just someone who wants to help share that story.

With *Crimes of Solidarity*, it was important for them to see themselves onstage on a scale larger than life, and that they were commanding an audience on their own terms. It affirms how they've been able to traverse the world and political structures—in order to be where they are, to survive, to migrate, and all the performativity involved in that act of survival. We all perform ourselves on a daily basis. This is something Claire Astier, one of the volunteer founders of Squat Saint-Just, reminded me of. For those seeking asylum or traversing the highly volatile political space of being undocumented, that idea of performing oneself is exaggerated tenfold. There's artistry in it, even though it's downplayed or denounced, and there's validity in it. This idea of opacity is really important—in the ways that Édouard Glissant has talked about opacity. We've been ordered to be transparent for so long that if we can create situations where we have control over our opacity/transparency, it can upend the ways dominant society thinks about our stories.

VC: Related to this is the idea of dialogue, which has been present in your films for a long time. You use it in different registers, often as a dialectical tool to argue out different points of view. But sometimes

it happens through the same enunciator, so in a multichannel work like *Specter*, if you look at one screen and watch the enunciator speaking, you might lose track of who's actually talking in that moment, and those different positions start to blur.[1] I'm curious how you came about using dialogue as a strategy and what you feel it does for your work.

TAN: Part of me is fascinated by the idea of empathy and the process of genuinely trying to understand multiple points of view. We get into trouble when we only think along singular lines from singular perspectives. The form of a dialogue is probably the easiest way to introduce dialectics and multiple points of view. We're taught in Screenwriting 101 that in each scene, there's got to be some conflict—that's probably the only thing I took from my screenwriting classes as an undergrad! And we can work through conflict using dialogue—that's where my fascination with dialogue lies. Conflict isn't always resolved in my own moving image works, but there's the potential for it. And the potential can only exist if it's not a singular point of view but multiple perspectives being worked out in dialogue. Somehow, in working through that, healing can take shape.

One of the recurring forms in my work is the epistolary form—letter writing. I did a project with the rapper Wowy a long time ago [*Letters from Saigon to Saigon* (2008)]. He's super well-known now, but he was young back then and wrote a letter to a rapper in New York called Saigon. We photographed the letter before he posted it, and in it, he talks to Saigon about his own history and wonders about Saigon's history, his moniker, and how he identifies himself. Wowy also writes about how he is influenced by West Coast rap, East Coast rap, Snoop Dogg, Jay-Z, and so on. I found it quite stunning how a simple letter could operate on so many different levels conceptually and socially and maintain an honesty.

Since then, a lot of letters have popped up in my work. In *Specter*, there's the letter that Macodou Ndiaye reads that was sent from his mother in Vietnam to his father in Dakar. And, as I mentioned earlier, the woman we're working with in Ba Vì in the north of Vietnam

is writing a letter to a father she never shared a word with. It's an interesting form to take—it's not quite a dialogue, but it desires to be a dialogue. It preempts dialogue.

VC: Letter writing is such an interesting bridge between some of your earlier work and the pieces you're making now. A letter can be cross-generational, even cross-dimensional—you're able to write to someone who may or may not receive it. Your early fascination with monuments also comes into play: monuments are, in some ways, large-scale letters or forms of saying "thank you" or speaking to the past—whether it's government-erected, self-made, or another type of transmission. The Ngurrara Canvas [featured in *We Were Lost in Our Country* (2019; p. 111–17)] is a sort of letter—while also being about claiming land heritage—which functions as a way of communicating to a future generation. This idea of the past-future continuum recurs in your work—acknowledging the connection between the past and future. It's never dystopian, but sometimes it sounds more hopeful than other times. And the relation between the past and future is not unidirectional; it's multidirectional.

TAN: You put it quite beautifully when you said that monuments are kinds of letters. We inherit them, and they're objects that travel space-time through generations. They function like the archive. I find myself really drawn to thinking about unofficial monuments as well, like the Ngurrara Canvas II, that are also recorders of history—in similar ways to how I look at personal family photos versus archival photos, for instance. The letter form functions similarly.

My mom left Vietnam without my grandmother knowing—she took off her wedding ring, wrote a letter, put it in my grandmother's closet, and just disappeared. It was the safest option because she didn't want anybody to be implicated in her escape with her husband from Vietnam. When they finally got back in touch again, she would write letters—that was their only form of communication. It took weeks to send letters back then. My mother would have us write a few words in English, too—most likely translated by her for my grandmother.

When I watched my mom write these letters, she would go through all these emotions—she would cry and laugh—and I would be mesmerized. It was like watching a film; it felt so big and important as a little child watching that process happen. When we received a letter back, it was such a big deal. A letter from Vietnam was like a letter from another planet. Maybe that has impressed letter writing on me—even though letters aren't relevant in today's age of technology, they're an ancient ghost-form; maybe letter writing itself is a form of speaking with ghosts.

VC: The other day, I was writing a text to express my gratitude for something. It's not like I was putting pen to paper—I was writing a text on the subway—but I started bawling. There's something about the act of addressing someone; you channel all of those emotions. They can pour out of you, and they're somehow activated. You're in dialogue with this entity that isn't there. The presence of ghosts, specters, or presences that aren't tangible, but are part of how we work through memory, is also something that interests me a lot in your work.

TAN: It's not dialogical, but it also is, in a way. You just mentioned you feel like you're entering a conversation with someone, but maybe the timestamp is different. Letter writing is a long, drawn-out conversation; it's super slow. It almost functions like a film still in the way it extends time. I think of Macodou and how many times he's read that letter from his mother, and how he reads it in the film. It's like a moment that he can loop himself into and out of over and over again.

VC: There's the translation in it as well—she's trying to communicate, but the French isn't precise. And he is also, to a degree, speculating what she's saying. He can understand it, but he has to fill in the blanks—especially with this being the only letter. It's a stand-in for all these other kinds of communications that didn't happen. And even with that singular letter, there's still a bit of a disconnect.

TAN: It's funny how he acknowledges on camera, "Oh, it's written in really bad French." And then he performs the role of translator.

VC: He reads both. He reads the original and then interprets it. Something about that really stuck with me.

TAN: It's really beautiful. Part of it is that he's trained as a lawyer, so he has to read the facts, and then he interprets them. The letter is a clue; it's proof of something. He takes it as evidence, but it's also material to be interpreted from not only an objective but also a subjective point of view. There's no escaping that subjective perspective because it's a letter from his mother. I find that kind of relationship and pivoting he does quite amazing. The scene of him reading the letter could have been its own piece—that's how strong I thought it was; it's super emotional.

VC: I wanted to talk about an idea you've mentioned in other interviews: the testimonial object. Oftentimes, you continue to develop your object-based practice after a film is completed, or some elements are brought into the film, and then you process the concepts and themes through objects afterward. This is relevant especially with the evolution of the sculptural works you've been making recently, which expand on how the objects are first engaged in *Unburied Sounds*.

TAN: I should probably stop using the term "testimonial object," because I'm likely butchering Marianne Hirsch's theoretical definition of what a testimonial object is—it's more complex than how I'm using it. When Hirsch developed this term and the whole concept of post-memory, she was thinking about objects that carry the memory and trauma of the people making them inside their materiality and in the process of being made.

VC: You can use it in the anthropophagic sense.[2] You've taken that idea, but then you've also embedded it with different ideas around animism.

TAN: Totally. My take on it is influenced by the idea of animism, a belief system that saturates all aspects of culture in this part of

the world. All objects have some sort of soul, spirit, intelligence, or memory—especially the ones we've made and lived with.

I also think about photographs as objects, especially photographs made before the digital era. There's a kind of fragility to them I hold dear. The only photograph that survived my family's escape by ocean was of me as a six-month-old baby, and it's the only baby photo I have. So, growing up, objects were always in danger of being destroyed. When I think about that photograph in the context of a testimonial object, I think about its journey of survival, which gives me some sort of anchor to a place and a time before I was "displaced" or "liminal."

In regards to *Unburied Sounds*, the objects the protagonist Nguyệt makes bear witness to her working through her own traumas. In the narrative, she's able to have them transcend beyond just that, so they operate on a different level. Part of me is obsessed with making these objects because it's an intimate process of imagining how Nguyệt would develop them. It's an attempt to empathize with this character who is fictional but based on real-life stories, to empathize with multiple people through the making of the object. The film also follows another short video piece [*The Sounds of Cannons, Familiar Like Sad Refrains* (2021; p. 181–89)] where an actual UXO [unexploded ordnance] found in Quảng Trị speaks and wonders about its next life. So it's even empathizing beyond the human.

VC: In some ways, you're imbuing Alexander Calder with way more resonance than his work had. You are asking, "What would it mean for these sculptures to emit sound frequencies and have those be a form of healing—using these materials of destruction in this different way?" The way you're using reincarnation is very particular.

TAN: I really appreciate how you've noted this as an act of decanonizing Calder and Western art history. Reincarnation is a big leap for a lot of people who don't grow up in a culture where you think about it every day. But as a narrative device, it can be quite effective because all these notions of identity can get completely destabilized

through it. Some of the things we hear as youths in cultures heavily influenced by reincarnation are, "You could have been my father in a previous life," "I could be your mother in another life," "We could have fought side by side on a battlefield hundreds of years ago," or, "A few hundred years later, we could have killed each other on another battlefield," and so on.

There's a fluidity of identity opened up through this concept of reincarnation. Things can flip around: I could have been a woman from Brazil in the late 1800s; you could have been a Vietnamese *tirailleur* in World War I—anything is possible. If you just consider it for a moment, a seed of empathy could be awakened through this narrative device called reincarnation. It's trippy for a lot of people, but I enjoy playing with it to resist dominant narratives, especially in art history, and especially in this particular instance. Dominant narratives are always trying to reinforce their positions, to maintain the illusion of stability and permanence—like monuments. To have such a major figure in Western modern art be positioned as a woman in the post–Vietnam War era, in the central region of the country, what does that do to the canon or our understanding of art history and history in general? How many ways can we topple monuments?

VC: What if she were coming up with this work not even knowing about Calder and not being his reincarnation? What would it mean to state that this is not unique genius, and that Calder's art could have emerged from anywhere?

TAN: Well, how does reincarnation function in that instance? My initial thought would be that she would be totally dismissed. That was going on in Vietnam for quite a while. Piracy of movies, music, and other things like furniture was really big here in the 1990s and early 2000s. Vietnam was vilified as the piracy capital of the world outside of China. Even some of the art being made here was labeled as derivative of Western art. So that was quite troubling. Maybe subconsciously, this was my response to that period and those accusations. The idea of a replica runs parallel to this idea of reincarnation. The West is so obsessed with the "original" and value.

Their "originals" were appropriations of art from Africa, the Pacific, and by Indigenous peoples around the world. But what about a replica? How can the idea of a replica undermine this obsession with the "original"?

VC: You really subvert the notion of the replica with how you've integrated the visual elements of Calder's mobiles but opted to activate them—especially when you think of Calder appropriating the idea of a gong for some of his titles. I'm curious about how your recent sculpture work has incorporated other elements, like brass artillery shells, and how you see it expanding on earlier iterations of the mobiles.

TAN: They all have a twist to them. There's a scene in *Unburied Sounds* where the protagonist tries to explain to her mother, "Hey, I'm not possessed. I'm not being haunted like you think I am. I know it's crazy, but I've followed your advice, and I've talked to all these people, and it turns out I'm the reincarnation of Alexander Calder. And doesn't it make sense? Don't his mobiles look like all the bombings and air raids you used to tell me about?" The notion of reincarnation as a narrative device can shift and undermine what we know.

And she does that in her recontextualizing of the Calder aesthetic. She goes on to further recontextualize it by using historically charged materials. So instead of working with any kind of metal, she uses metals she's obsessed with, that are abundant to her, and have caused trauma for her family—metals from UXO and old brass artillery shells. Those two shifts pull the rug out from under us, from our understanding of what we have been taught in art history, and what has been prioritized in that education, pushed to the forefront, and left behind.

But then it wasn't enough to leave it there; she had to change it yet again. And she does so by tuning them, by understanding sound healing through a monk whose character is based on the well-known Buddhist monk Thích Nhất Hạnh. He's from the central region of Vietnam, close to where we were shooting, and had

returned to live out the rest of his life there. On our last day, we got news he had passed away no more than fifty kilometers away.

He was an amazing thinker and really informed about the break-throughs of science. He always talked about sound, resonance, particles, and waves. So the scene in the film where she talks to the monk is based on Thích Nhất Hạnh and his theories of how we are material and immaterial at the same time. Nguyệt then takes the mobiles to a whole other level and gives the objects more function-ality within this context. It's not just that sounds can heal—these frequencies are also being emitted from particular materials with a specific history, and it reflects how that transformation can be an act of resistance.

VC: It connects again to the ways your work has examined dis-ciplinary bounds, and the fact that Western cultures, especially, have implemented structures of categorization and naturalized the amassing of objects or knowledge. There's something powerful about your works existing in an art-institutional space and desta-bilizing some of those logics. This also connects to your interest in history museums and so-called "ethnographic" museums. There is an urge to limit these objects to a place where they can be viewed, studied, and witnessed in a particular way, which dissociates them from peoples and histories. As much as these spaces are claiming to be historical records and keepers of that, they're actually creating a degree of removal from those realities. You've used replicas as a way of saying, "Well, if we don't have access to the original, can we imbue these other objects with the same power? And why does the 'original' have the power? What does it mean to take ownership of that and do something with it?"

TAN: Completely. Historical museums, ethnographic museums, and even art museums supposedly tell the one and only story. But behind that are many stories—mostly of thievery, destruction, damage, trauma, looting, and all sorts of other harmful deeds through the accumulation of these objects. We can start to think about the repair—repair of colonial trauma—through looking at the objects.

There have been a lot of conversations about restitution. I'm interested in how the objects function within the narrative that the museum is dictating. But I'm also interested in the narratives the museums are trying to erase through the objects they possess. The museums tell the story, and in order to tell it the way they want, a lot of other stories are literally buried. My obsession with objects in museums is about uncovering the other stories being held in the items, figuring out ways to liberate them.

VC: This might be a leap, but I wonder if that connects to your interest in music as this other register of memory, history, and a particular moment that escapes that level of capture? I've also been curious to hear more about your use of Trịnh Công Sơn's music and Khánh Ly's performances of them.

TAN: I think about music in the same way that people think about smells, and how smell has a direct way of triggering memory. Song does that for me; it contains words that are poetic, interpretive, and transmit more on a political level. I think of protest songs, like Billie Holiday's rendition of "Strange Fruit."

The songs I use a lot in my work—like by Trịnh Công Sơn and Khánh Ly—triggered my parents' generation and, in turn, triggered me because I witnessed them trying to maneuver themselves when they were in their early to mid-twenties. They were boat people, refugees, immigrants in a country also trying to come to terms with its own trauma of the war. It was a complicated political landscape. Most of the songs written by Trịnh Công Sơn were anti-war, and a lot of his music was censored in the south during the war and then by the north after the country was unified. But these songs somehow resonated not only because they carried a political message—when you sing a song, any song, you embody that message and memory. It's almost as if you become a vessel for some kind of ventriloquism. There's an embodiment to that, and it's about performance, enactment, reenactment, amplification, and multiplication.

I'm a big believer that listening to a story is a basic initial step toward empathy, this theme I mentioned earlier. And when there's empathy, there can be solidarity. So listening to a story could be as politically powerful as telling a story, and listening to someone sing could be as powerful as joining someone in protest.

VC: I'm excited to be showing *Unburied Sounds* and *Specter* together for the first time because they present different reflections on the aftermath of war. The new project, centered around the Moroccan Gate, is also related to *tirailleurs*, similar to *Specter*, but coming from a different context.[3] And both histories of *tirailleurs* reflected in these two projects are, of course, connected to French imperial impact and colonial rule—specifically, the First Indochina War. I wanted to talk a little bit about what it means to bring these three projects into dialogue with each other.

TAN: These three projects together tease out the complexities of the aftermath of colonialism and war, connecting Vietnam, Senegal, Morocco, France, and the US. Our main collaborator for *Because No One Living Will Listen*, Habiba, is half Moroccan—her father was a Moroccan soldier that defected from the French army, which is the counterpoint to what happened in Senegal. Most Senegalese soldiers returned to West Africa, many bringing their children with them. In the case of the Moroccan soldiers who defected, they stayed in Vietnam. They weren't repatriated until 1972, almost twenty years after the war ended in 1954—and many were not able to be repatriated. Some had also died, and some didn't want to go. There are stories about Moroccan soldiers hanging them-selves because they didn't want to return to Morocco; other sources suggest the suicides happened because they felt imprisoned in Vietnam. Even though they were officially "free" men, because they had fought for the French, they were always under the careful eye of the government. So there are lots of complex stories that instrumen-talize this particular moment in history and this community.

I hope this project complicates and expands our understandings of what happened in this twenty-year period. When the French were

defeated in 1954, less than ten years later, the Americans were here, and that war lasted ten years. These Moroccan soldiers, and by extension, Habiba, lived through the American War before they were repatriated. I don't know if that's going to be teased out in the conversations she has with her dad through this letter. But the objects, the architectural monument, the Moroccan Gate built by these Moroccan soldiers are another way of dealing with this idea of a narrative, an object of testimony, a memorial, and a monument all in one.

VC: And a letter.

TAN: And a letter. There's something quite interesting about these three points of history being positioned and woven together in the show.

VC: I read elsewhere that there was a moment when you connected the dots to stories you had heard and realized, "Maybe my granduncle was a *tirailleur*." It's powerful how your projects also help you tap into your own family history.

TAN: Yeah, my granduncle was recruited and forced to fight at Điện Biên Phủ for the French and then ended up in Algeria during the revolution and then Martinique. He was a really interesting man. Understanding my own personal family history is a way of understanding the larger history of colonization and migration. I'm taking the opportunity and making an excuse to work through both types of histories.

1 In *The Specter of Ancestors Becoming*, a panoramic, four-channel video installation, multiple actors mouth words spoken by a single narrator who is heard in voiceover.

2 "Anthropophagic," as used here, alludes to the concept of *antropofagia*, coined by the Brazilian poet and polemicist Oswald de Andrade in his 1928 "Manifesto Antropófago" (Cannibal Manifesto). It refers to an early twentieth-century movement that emerged in Brazil describing a metaphorical cannibalism: the cultural and artistic "consumption" or appropriation of foreign influences and ideas alongside local ones to create distinctive new forms.

3 The Moroccan Gate is a monument located in the Thang Long Citadel in Hanoi, Vietnam. The gate was constructed in 1959 by Moroccan soldiers who were part of the International Control Commission, a multinational organization established to oversee the implementation of the Geneva Accords, which ended the First Indochina War and called for the withdrawal of foreign troops from Vietnam.

Give the Body Back

—

Zoe Butt

How do we give the body back to the images that define us?

How do we re-embody the fragments of our memories into some semblance of meaning?

Is our sense of self not reliant on our need to be of membership, in kinship, with community, in the worlding of human action and its legacy?

Why is it so necessary that we ask such questions, today, as we sit on the precipice of the oblivion of humanity and its habitat?

Spending time with the historical insights and speculations of Tuan Andrew Nguyen, I have found hope and resilience in attempting to answer such questions in the face of human short-sightedness. In spite of the violence inherent to the excavation of colonial patriarchy and its social repercussions—an aftermath evocatively recalled through Nguyen's moving images and associated testimonial objects—I have found solace in his particular relationship to the meaning and role of existence. For in his world, there is comfort to be found in being present with what we cannot see, a space of hope that recasts the capacity of our reality beyond what is allowed to be visible. Anchored in this is a belief that the animate and inanimate worlds are inimitably, cyclically linked to not only the intergenerational spirits of our ancestors, but also that such worlding defies the systemic order with which our extractive attitudes are capitalistically governed.

In Nguyen's art, history reincarnates—descendants of colonial couplings are given the right to voice hidden, social, at times imagined realities (see *The Specter of Ancestors Becoming* [2019; p. 129–61]); unexploded ordnance is recycled into musical instruments of healing (*The Unburied Sounds of a Troubled Horizon* [2022; p. 191–225])—transferring life, and, thus, memory, with a conscience. In his art, the materiality of human need and attachment is challenged, provoking the power of consciousness as both a human and nonhuman presence and enabling the memories that cycle in our

dreams to be told in ways that defy linear perceptions of mediated reality and its presumed coordinates. Nguyen conjures social worlds that give space for redemption in our relationship with the material constructs of human destructiveness—its mechanical creations, toxic waste, historical ruins, documentary evidence. He conjures empathic pathways with which to live with human arrogance, in reconciliation of its myriad violent historical consequences. In his art, the materiality of pain and loss cannot be a keepsake, not an image memorialized in stasis—for Nguyen, there can be no replica, only transformation.

To begin answering how and why he does this, it is useful to listen to the protagonists of Nguyen's filmic dramas, how they challenge the representation of "History" through their very voice (which he often crafts as dialogue embodied by another's consciousness), and to appreciate that such embodiment is often in commune with what is inanimate, or presumed dead. And yet this dialogue is most definitely alive. The power of his evocation of the intangible as a parallel dimension, where the future is past and yet indelibly now, emotively provokes audiences. In our resource-depleting universe, where the systemic argument of cause and effect is governmentally enforced by its scientific measurement of the visible, Nguyen's revelry in the historical dimensions of presumed irrevocability is astute. In *The Boat People* (2020; p. 101–09), an ancient stone goddess, colonially disembodied, is discovered by a future lone human washed up on a seashore, who speaks in warning of the past. In *The Sounds of Cannons Familiar Like Sad Refrains* (2021; p. 219–27), unexploded ordnance speaks in aural memoir, lamenting the humans who fail to understand its grief in being left alone and forgotten. And in *My Ailing Beliefs Can Cure Your Wretched Desires* (2017; p. 181–89), spirits of extinct animal species sneer at their murderers, mourning their exploited relevance in a symbolic world oriented by, and for, humans and their cultivation of fear and destruction.

In Nguyen's art lies a social resistance to the trappings of colonial hegemony and its racial/spatial/time divides that deems material culture and the debris of History anthropologically, politically,

spoken for (thus, owned) and archived (belonging to the past). He conjures a reconnect between the living and the dead, which attempts to ease the conflicting curse of trauma in their denied legacy. Denied legitimation to write their own stories, denied a right to bury their own histories, denied a right to defend their choices made in the face of cultural superstition and discrimination, Nguyen's protagonists are given agency to word historicity—repopulating History's consciousness of social relations between the seen and unseen. This reconnecting between human and nonhuman, living and dead, perceived past and imagined futures is a playground of multiplicity ensconced in a reality sensitive to animistic paradigms, dancing in a landscape of forgetting.

In *The Specter of Ancestors Becoming*, Waly emphatically states, "Forgetting is a choice," as he circles his kitchen in 1954 Saigon, attempting to convince his Vietnamese wife that their forthcoming, enforced, new life in Dakar will never replace her attachment to her people. It is a sentiment desperately echoed by Madou, who confronts his Senegalese father in frustrated lament of his calculated decision to bury the existence of Nguyen Thi, his Vietnamese birth mother (subsequently, he refuses to abide by his father's erasure by naming his daughter in his mother's honor). Both of these imagined scenes are written and narrated by the living descendants of fraught couplings between colonial soldiers and colonial subjects. Nguyen's empowering of such kindred, in collective spirit, is tantamount to the evidential address of art as a critical process of authenticating the past, and I can hear Donna Haraway uttering, "It matters what worlds world worlds. It matters what stories tell stories."[1] Just as Walter Mignolo emphatically reiterates, we must "change the terms, not just the content of the conversation"[2] in the decolonization of our minds.

In *The Unburied Sounds of a Troubled Horizon*, a Vietnamese monk explains to Nguyệt[3] why there is an unexploded bomb hanging at the entrance to his temple in Quảng Trị: "A young monk at the time [1968] . . . saw the immense compassion embodied in the bomb, because it chose not to explode. He turned it into that bell to remind everybody of the power of compassion." And thus, a bomb becomes

a blessed object that proffers healing through sound in a sacred space whose limbless temple-goers struggle in a landscape over-ridden by unexploded ordnances (UXO) and the residual chemical toxins of warfare.

In both *The Specter of Ancestors Becoming* and *The Unburied Sounds of a Troubled Horizon*, the need to "re-member" and for-give—to give the body back to the pain of loss at the hands of human atrocity—is paramount. I say "re-member" and not "remember" for, in both narratives, there are particular characters whose (personi-fied) presence is crucial in the telling of such destructive histories: the imaginations of the Vietnamese-Senegalese community speak-ing of their own denied ancestral memories; and the humanizing of an unexploded bomb-now-bell, whose healing emanations are believed to cure the victims of its brethren. Such landscapes of relationality that recall both human and environmental trauma in personification, evinced through the moving image, are described by May Adadol Ingawanij (who refers to Isabell Herrmans) as a "cinematic animism," stating:

> When reality is contingent and impossible to foresee, and the world as locally experienced is increasingly unpredictable, the continuing maintenance of communicational relations with spir-its becomes a form of agential and temporal practice sustained by those who are most vulnerable. Humans' maintenance of the capacity of ritual to address spirits, and to sensorially perceive communicative exchange with them, constitutes a mode of pre-carious becoming, a way of harnessing the prospect and hope of the continuing liveability of one's life and one's habitat as well as an orientation towards possible futures.[4]

In Nguyen's art, the spirit world is not recalled via spiritual doctrine or ethnic myth; rather, it is an engagement with the conscience of History, its spirits channeled in order to redetermine life beyond the presumed codes and categories of "Being," "Justice," and "Reconciliation." Such an animistic approach to materiality and memory sits at the core of Nguyen's arrest of the image and its

physical attestations. In the project *Empty Forest* (2017), a creature of bamboo and jute stands in as the wandering spirit of the last Javan rhino on the Asian mainland; its thoughts crucial to the script of the project's associated video installation *My Ailing Beliefs Can Cure Your Wretched Desires*. This protagonist is haunted because it cannot bury its own body—such materiality sitting encaged as anthropological specimen.

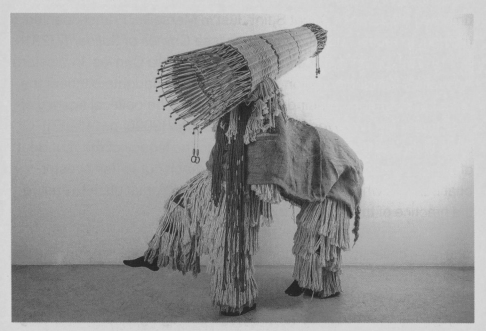

Spirit of the Last Rhino / Linh Hồn Tê Giác, 2017. Bamboo, cotton rope, burlap, bells. 72 ⁴/₅ × 23 ³/₅ × 74 ⁴/₅ in (185 × 60 × 190 cm). Exhibited with mannequins

Nguyen gives this ghost animated presence with the associated exhibition as a kind of shamanistic ritual, as its body is embodied (performed) on opening night. This spirit lingers in a type of limbo within the forgetful space of unreconciled trauma, seeking reincarnation. As Nguyệt recalls, "When you try to forget, you end up remembering more. So, it's better to remember, so that you can forget." Nguyệt is alluding to the process of decolonizing History—which we, its subjects, must recall (as Mignolo insists)—by changing the terms with which we are permitted to re-member; thus, enabling redemptive space with which the past can be reconciled and consequently transformed.

To give such body back to memory takes collective work and collaborative thinking. It takes time, sensitivity, and criticality. And much of Nguyen's artistic practice revels in—indeed, relies on—a deep dive into social prisms of contested space and its hidden, discriminated, overlooked narratives by direct engagement with lived experience. This entails extensive situated research with disparate community, spending time with those whose tales powerfully proffer evidence of resilience in the face of systemic injustice. This includes the undocumented migrants of Squat Saint-Just in Marseille, France, denied the right to receive public assistance (see *Crimes of Solidarity* [2019; p. 119–25]), or the dying authors of the Ngurrara Canvas, in Western Australia's Kimberley region, whose sons and daughters inherit the colonial castration of their dreaming, despite the political agency of their forebears (*We Were Lost in Our Country* [2020; p. 111–17]). Or there is the artist's ongoing research into the legacy of the "Luf Boat" of Papua New Guinea, which led him to reach out to its ancestor boat builders who desire repatriation of the colonial prize to ensure the practice of this situated memory lives on.

Nguyen's collective re-membering of human agency is prompted by objects and sites whose social worlds live on the margins of History, whose histories are yet to be written by its subjects. His direct engagement with such community—encouraging reflection, writing, performing, sharing evidence of experience—provides a process of catharsis for those whose voices are little recorded. But does he have the right to prompt and represent what is predominantly the incredibly traumatic experiences of others?

Believing in the power of art to impel redemptive control of the images that determine who we are—and as a Vietnamese boat refugee who harbors his own traumatic memories of fight or flight—Nguyen's sensitivity to the crafting of script (giving his subjects authority through voice, text, sound) is what gives agency to those he is inspired to represent. Thus, the praxis of his protagonists as collaborators, fellow researchers, and often cowriters, whose memories and motivations recall the spirits of their ancestors and their lived realities, presents Nguyen as a kind of conduit for the rewriting,

or repopulating, of History. This process of building friendship, of conjuring pluriversality, as a process of collaboration (as opposed to observation or empirical deduction) is not only a methodology for Nguyen to engage minds met in the flesh but also with those who have left a textual trace.

Nguyen is intellectually inspired by his grandmother's poetry of resistance, the lyrical revolutionary ethos of Vietnamese musician Trịnh Công Sơn, and fiction writers such as Octavia Butler and her crafting of time travel as a means of revisiting slave narratives.[5] Theoreticians such as Thien Do and his belief in *linh*, where supernatural power can impact the living world, and historians such as Marianne Hirsch and her study of post-memory and the role of objects (as "remnants," particularly) in telling histories of resistance are also of influence.[6] Nguyen's overall dialogical realm is an essential means of worlding, of building critical community, which fundamentally hones his own purpose and self-discovery.

"We not only interrogate each other, we interlocate each other," writes philosopher Mikhail Bakhtin, whose theory of the dialogical follows his study of human subjectivity and the unique "situatedness" of one's perceptions, which can only be understood as whole once one's perceptions are understood from another's perspective.[7] Bakhtin draws a distinction between experience and the reflection of experience—we must simultaneously assess "things" and the relations between them. Bakhtin is compelled by the architectonics of perception (the "ordering of meaning"), which he deems the activity of relations between entities (material and immaterial) and how they are built, perceived, and articulated, believing the conceptual whole of a text (or an artwork, for example) must be inclusive of what the artist *does not* render. This is because the interlocation that informs its existence (the intangibility of the "dialogic") is a form of labor that has enabled that "whole," that "text."

This is about valuing the communities that give birth to memory—the sharing of perspective in all its sensorial recall and enunciation—beyond what is tangible, marketable, and, thus, visible. Recognizing

the relations between "things" being tantamount to that "whole" and its ability to circulate with meaning in the world is evidenced in Nguyen's creation and circulation of *The Specter of Ancestors Becoming*, for example. Seeking its exhibition in Dakar (beyond the site of its commission in Sharjah) for the very community that contributed to its birthing was ethically critical for the artist. He gave back his documentation of their memories, whose presence has little historical registration, by not only displaying this work where it matters most but also providing the community with the research (unedited interviews, notes, photographs, sounds, and more) for them to own and circulate.

Immersing his practice in the collective realm of such critical relational dialogue spurred Nguyen's cofounding of Sàn Art in Ho Chi Minh City in 2007. This small gallery, reading room, and group critique space was once the most significant gathering place for artists to talk, share, present, and learn. It also prompted his cofounding of The Propeller Group in 2006, an artist-collective-cum-fake(?)-advertising-agency that provoked how knowledge is driven, circulated, or usurped by media landscapes and their political/ideological constructs, organizing myriad interdisciplinary "marketing strategies." Since 2015, his learning with community has taken a different approach, with a more poetic engagement of the collective agencies afforded between what is present and deemed absent. This is driven by a personal need to connect his own experiences to a wider geopolitical fabric, aware that the calamities of human neglect are repetitive global syndromes. If there is to be hope in the world for future generations, someone must give picturing to its precarious interlinked possibility by empowering those whose race, class, gender, beliefs, or objecthood lives in the shadow of hegemony and its exploitative carelessness.

"We cannot imagine a world without humans. It's beyond us. It's the bug in our programming. It's our trap and our downfall,"[8] shares Nguyen. This sentiment is poignantly reflected in *The Island* (2017; p. 93–99), where the last man on earth walks Pulau Bidong, a Malaysian island once a haven for thousands of Vietnamese boat

refugees. Nguyen's tale offers documentary historical reportage of this human calamity, as his lens sensorially embraces the sounds of the forest and the myriad religious and personal monuments left engulfed by nature, devouring any human trace. The lonely scientist reflects, "The last wars made refugees of the entire world," and it is perhaps in direct response to such dystopian (yet entirely probable) mass displacement that Nguyen's ensuing artistic fabulations have attempted to not only act as prophecies of this potential reality but also render where alternate resilience and survival can be found. This is a resilience in listening, in seeking dialogue with those whose memories can powerfully challenge the assumptions of History. Such evidential arguments must be challenged by the affective realm of experience, as Carolyn Pedwell shares: "Emotions are not universal, as dominant liberal and neoliberal narratives of empathy would have it, but rather radically shaped by geo-political relations of history, power and violence."[9]

Recognizing the immense effort and commitment undertaken in the situated learning of an artist's creative practice should better compel the value systems of art today—to give the body back to the process of making by encouraging the globalizing art world (with its powerful bias toward what is tangible and, thus, visible) to support and give recognition to the social worlds integral to an artist's existence. The art of Tuan Andrew Nguyen advocates for culture as a liminal space of transformation. It provides an opportunity for us to encounter ourselves—our beliefs, principles, values—in the perspectives of others, to ultimately confront our own reliance on what is known and certain in a world that is entirely unknown and uncertain.

1 Donna J. Haraway, *Staying with the Trouble: Making Kin in the Chthulucene* (Durham, NC: Duke University Press, 2016), 35.
2 Walter Mignolo, *Local Histories/Global Designs: Coloniality, Subaltern Knowledges, and Border Thinking* (Princeton, NJ: Princeton University Press, 2017), Location 1965, Kindle.
3 A Vietnamese woman who lost her brother to a landmine and whose family's livelihood depends on her recycling scrap metal from exploded remnants of war.
4 May Adadol Ingawanij, "Cinematic Animism and Contemporary Southeast Asian Artist's Moving-Image Practices," *Screen* 62, no. 4 (Winter 2021): 553.
5 Trịnh Công Sơn was a Vietnamese musician, painter, and poet widely considered to be Vietnam's best songwriter. His music explores themes of love, loss, and anti-war sentiments during the Vietnam War—for which he was censored by both the southern Republic of Vietnam and the Socialist Republic of Vietnam. For more on Octavia Butler, see *Kindred* (Boston: Beacon Press, 2003).
6 See Thien Do, *Vietnamese Supernaturalism: Views from the Southern Region* (Abingdon, UK: Routledge, 2014). See also Marianne Hirsch and Leo Spitzer, "Testimonial Objects: Memory, Gender, and Transmission," *Poetics Today: International Journal for Theory and Analysis of Literature and Communication* 27, no. 2 (June 2006): 353–83.
7 Mikhail M. Bakhtin, Michael Holquist, and Vadim Liapunov, *Art and Answerability: Early Philosophical Essays*, vol. 9, *University of Texas Press Slavic Series* (Austin: University of Texas Press, 1990), xxvi.
8 Tuan Andrew Nguyen, "Empty Forest: An Interview between Tuan Andrew Nguyen and Zoe Butt," Factory Contemporary Arts Centre, 2020, https://factoryartscentre.com/wp-content/uploads/2020/05/ENG_Interview.pdf.
9 Carolyn Pedwell, *Affective Relations: The Transnational Politics of Empathy* (London: Palgrave Macmillan, 2015), 108.

Common Ground

—

Eungie Joo

The Specter of Ancestors Becoming (2019) opens with Macodou Ndiaye reading the "last" letter from his mother to his father, eight days before he is born (p. 134–35). In it, she reminds "Diaye" not to forget her, that she will care for the child well, in hopes they will be reunited. She admits fear and sadness at being left behind but also confidence that this child will keep them connected. In the four-channel work, footage of Ndiaye, now in his sixties, contextualizing and reading the letter is cut with a photo of a woman carrying an infant, images of the father as a young soldier, a portrait of the mother, details of the letter, a photo of the baby, a scene of Ndiaye practicing Võ Vi Nam[1] alone at night, and, finally, the mother's name and address as she signed her last letter. As he reads, Ndiaye holds the worn letter close to his face, reading with certainty and experience. He is holding proof of a life before him, one that he had to imagine from this half of a correspondence.

In his research into the shared colonial pasts of Africa and Indochina, Tuan Andrew Nguyen came across a photo of prisoners of war from the French colonial corps, which made him go searching for evidence of a solidarity of intuitions[2] among these subjects (p. 164–65). Infantrymen of the French colonial empire, the *tirailleurs sénégalais*, were the last defenders of French military rule in Indochina, now Viet Nam, until the fall of that regime following the loss of Điện Biên Phủ in 1954. Nguyen hoped to document stories of *tirailleurs sénégalais* and *tirailleurs indochinois* fighting alongside each other and searched for evidence of Senegalese soldiers leaving their posts to join the Viet Minh resistance. Instead, he uncovered a complex web of loss rooted in colonial prejudice that continues to inflict wounds on its subjects to this day. When the *tirailleurs* returned home to Senegal, they took with them hundreds of Vietnamese wives and children. These transplants often faced violent treatment from their new families; cultural and linguistic differences exacerbated by class and religious discrimination.

Eventually, the Vietnamese women found each other and formed a unique community of shared customs and language for their children.[3] When Nguyen accessed this community in 2018, he learned

about many incomplete chapters and inspiring continuities despite hardships and longing. Embracing the not-quite-knowable, Nguyen worked with members of the community to write their stories into three main storylines as a way to construct memory as it might have happened but could not.

In the first episode of *The Specter of Ancestors Becoming*, we see Anne-Marie Niane reading the staging notes at a recording studio: "INTERIOR. APARTMENT, SAIGON – NIGHT," as a young woman, Lan, is projected on the screen opposite, washing dishes. Niane continues to narrate the scene as the male protagonist, Waly, enters the kitchen and begins to explain their imminent departure (p. 138–39). While he speaks through Niane's voice—"It's not me who decides whether to leave or not. I am subjected to the course of history"—black-and-white photographs and film clips of ships and soldiers, planes and civilians continue across the other screens. Images move from one screen to another, operating, at times, like a jump cut or coordinated to produce a sensation of floating between the four screens that surround the viewer. Waly is framed by two, then three competing angles of the same scene, with only a slight variation in perspective.

This doubling and tripling expose the scene to time, place, and artifice; the camera's repetition emphasizing failure. The shifting of activity on the screens is enhanced by a temperamental soundscape—part siren's song, part shaman's bell—that moves with intention around the space. Niane is the teller of an imagined interaction between her parents—a creation story for the family's departure from Saigon to Dakar via Marseille. Crafted with historical resonance by Nguyen and Niane, the couple's argument reveals the shared, unique, and contingent experiences of those subjugated by the French. Buried within the decisions of a father that oblige a mother's eventual compliance, we are shown the resistance of many wives who knew, in exchange for their immediate safety, "Viet Nam will be lost for me and my children."

The second storyline returns us to Macodou Ndiaye, who shared his mother's letter in the opening sequence. For his vignette, Ndiaye narrates a confrontation that could not take place during the lifetime of his father, Ibra. Through this impossible conversation, Ndiaye's thirty-year-old self—"Madou"—is able to step out of line, to act disrespectfully, to name his suffering for a loss he was not allowed to acknowledge. Now the age of his father in this story, Ndiaye is positioned to express the passion and conviction of a younger self, naming his daughter after her biological grandmother—though her name has never been spoken in the family.

As this memory of a rigidly conservative Ibra—who asks to see his granddaughter in one breath and complains of her mother's low caste in another—develops, two dark screens switch on to reflect the present. One features Ndiaye being embraced and kissed by his daughter, then other children and grandchildren. The opposite projection shows Ndiaye and his son practicing Võ Vi Nam in slow-motion, unhurried, timeless (p. 144–45).

All the while, the scene of Ibra's and Madou's reckoning continues to unfold: the son chastises his father for hiding his mother's letter and not admitting its existence after he found it ten years earlier. For Ibra, he has saved his son's life by bringing him to Dakar to study and succeed. "What are you missing?" He continues, "Do you think it's easy to forget certain parts of your life? I am not the evil man you have created in your head. In war you have to make certain choices." Here, the gap between father and son is at once impassable and reflexive. Though the character of young Madou takes a judgmental position against his father, as narrator, Ndiaye is reconciled to Ibra's limitations. "Forgetting is a choice," insists Madou. "Sometimes you do not have a choice but to forget," responds Ibra.

Nguyen Thi is the unacknowledged mother, her name bestowed to a new generation as a choice of remembering. Even as Ndiaye stands with his children carrying a photo of his mother—evidence of the cultural and emotional transmission he has achieved across generations—his younger self has grief yet to express. On an adjacent

screen, he impugns, "So thank you father, for having deprived me of a life. Yes, a life. Never to remember the smell of my mother's skin, the scent of her hair, the tone of her voice. What will I say to my children about their grandmother?"

It is only in the third storyline that the past begins to be released from its mistakes and is allowed to endeavor prophecy. Based on Merry Bèye Diouf's memories of combing her grandmother's hair after lunch with her sisters, this passage proposes understanding across generations despite the many silences kept about Viet Nam (p. 154–55). Grandmother Maam asks Fatima, "What do you remember?" She recalls: "I remember you stood in front of a rifle to save a black man." Eventually, Fatima embodies two women and assumes the voice of all periods and people. Granddaughter, grandmother, and grandfather collapse into each other's stories, remembering (for) each other.

"Did the black soldier return?"
"I remember."
"I returned to Senegal with my wife and my three children."
"What do you remember about the wife?"
"The love of my life. The one who saved me."
"I remember the story. I became a grandmother."

Fatima continues to recite the lessons of her grandmother's life, including her fourteen children, thirty-four grandchildren, and forty-six great-grandchildren. She remembers that she is ninety and her dream of returning to Viet Nam died a long time ago, that there is no shame in the journeys we have taken, that she does not like to speak of Indochina.

Fatima asks, "Do you remember the future?"
"I remember there is an invisible tribe."
"Do you remember what you have done?"
"Senegal, filled with my blood, that will never be the same."

In 2018, I arrived in Sharjah to attend the March Meeting and was asked if I could fill in the following day for an artist who had just canceled. By incredible coincidence, Tuan Nguyen and Wu Tsang were both in town for site visits for the next biennial and agreed to share the stage. The next morning, before our panel, we attended a conversation between Salah Hassan and Manthia Diawara on the legacy of Black intellectual thought and forms of solidarity in their respective work. Diawara discussed the idea of solidarity in the work of poet and philosopher Édouard Glissant as a trembling that we share with other humans, animals, nature—your most secret intuition that someone else is also feeling in another city, country, or universe. He explained Glissant's insistence on recuperating orality and nonrational thought and queried, "So how do we create a solidarity between intuitions? This is what we are not daring to do today. How do we connect these intuitions that are *against* different things, but intuitions that are also *for* different ways of being in this world?"[4]

Tsang, Nguyen, and I worked together on the 2012 New Museum Triennial and all knew each other from the early 2000s, when they were graduate students and young artists in Los Angeles. In our talk later that afternoon, we acknowledged Diawara's provocation as a path upon which we had each embarked to find each other.

By the time I met Nguyen at the California Institute of the Arts in 2003, he had already studied under Daniel J. Martinez at the University of California, Irvine, already decided to abandon a track toward professional Muay Thai fighting, already started to think about a return to Saigon. He registered for my graduate seminar on rethinking identity politics and race in contemporary art with maybe two other students. I remember that I was a bit let down by the slim showing but cannot recall how that first class went. By the next session, there were about a dozen students, and I remember telling one of my closest friends that the critical mass of artists of color we had been waiting for was finally here.

It turns out Nguyen—out of concern that the course would get canceled—rallied his fellow students to attend the course. He knew that

if they did not show interest by registering in numbers, the school could ignore the students' critiques of the program. Though we did not speak of it at the time, I was very aware of his intervention— leaked to me by his peers. I witnessed his horizontal leadership and understanding of the generative power of the collective. But I also witnessed his profound commitment to his art practice and ambivalence toward measures of success that informed the ambition of many others.

Nguyen's predilection for motivating group action without sacrificing his own philosophical, ethical, and conceptual ideas would lead me to recommend him to SUPERFLEX when they needed a Director of Photography to shoot their Guaraná Power commercial with farmers in Maués, Brazil, in 2004. It would lead Nguyen to form The Propeller Group in 2006, a platform for collective art practice, commercial production, and other lines of collaboration with artists, performers, and creatives that he maintains to this day. It would influence his cofounding of the then-artist-led platform, Sàn Art, in Ho Chi Minh City in 2007. It would keep him thinking, listening, learning, making. And it would guide him to develop a rigorous artistic practice that is transdisciplinary, attentive, and deeply empathetic. A practice that trembles with those who want to remember and those who cannot forget.

1 The traditional Vietnamese martial art, which was eventually mixed with kung fu.
2 A term coined by Manthia Diawara at March Meeting 2018: Active Forms, Sharjah Art Foundation, March 18, 2018. See Manthia Diawara, "Édouard Glissant's Poetics of Trembling," in *Soft Power: A Conversation for the Future*, ed. Eungie Joo (San Francisco: San Francisco Museum of Modern Art in association with Rizzoli Electa, 2019), 10–15.
3 As that immigrant generation began to leave this world, their descendants founded Kim Hoi (the Golden Union) to maintain their unique cultural roots borne of interlocking colonialisms. The Senegalese-Indochinese association Kim Hoi was founded by Marie Thiva and fifteen others in Dakar on November 26, 2016.
4 Manthia Diawara, in conversation with Salah Hassan, March Meeting 2018: Active Forms, Sharjah Art Foundation, March 18, 2018.

Tuan Andrew Nguyen and His Collaborators, Caught in the Throat

—

Catherine Quan Damman

INT. APARTMENT, SAIGON – NIGHT.
INTÉRIEURE. APPARTEMENT, SAIGON – NUIT.

WALY
I am subjected to the course of history. We've lost.
Je suis soumis a cours de l'histoire. Nous avons perdu.

LAN
We?
Nous?

WALY
You know what I mean.
Tu sais ce que je veux dire.

This exchange between Waly (Ibrahima M.F. Ndiaye) and Lan
(Carmen Barry) occurs early in Tuan Andrew Nguyen's 2019
four-channel video installation, *The Specter of Ancestors Becoming*.
It offers many of cinema's confections, foremost of which are two
beautiful faces, radiant in soft light. The kitchen in which they are sit-
uated is welcoming and lived-in, though the camera roves anxiously
through the space. We see Lan first, from outside the window while
she washes dishes, her back to the door; when Waly enters, she
does not turn to greet him (p. 138–39).

In these few sentences are compressed the primary elements of
Nguyen's artistic inquiry: the enormous force of history as it pres-
sures the individual or assays the tensile bond between intimates
("I am subjected to the course of history. We've lost."); the uneas-
iness of the pronoun, as it alternatively hails, excludes, or indexes
a fracture ("We?"); and, above all, the many warps of ordinary lan-
guage ("You know what I mean"). Quivering below every attempt
at communication, misunderstanding lies in wait. In her reaction to
Waly's insistent "You know what I mean," Lan, the audience is made
aware, discerns her husband's semantic meaning. On a more sig-
nificant register, however, she does *not* understand his reasoning,
his choices, or the widening gulf between them. She knows what he

says but not why or how he got there. These are the shores on which so much—intimacy, solidarity—founders.

In *Specter*, the stakes are higher than the travails of ordinary marriage. Waly is eager for them to board the *SS Pasteur*, departing in three days' time. The name of the ocean liner places the scene sometime between summer 1954, following the French defeat at Điện Biên Phủ, which marked the end of the Anti-French Resistance War (known in France and elsewhere as the First Indochina War), and September 1957.[1] Waly hopes they can secure coats for their children, who will need them in the chillier climes of Marseille, the port city through which they must pass on the way to their final destination, Dakar. The itinerary would bring them to Senegal, Waly's home; refusing to embark would keep them in Vietnam, which is Lan's. The conversation is freighted with what was once the blush of romance, now exsanguinated. Just as Lan cannot understand his desperation to leave, Waly cannot abide her logic—we see flashes of rage about what it has meant for him to live in this place. Later in their conversation, he seethes, not wrongly, "I'm French only when they need bodies to take bullets." Waly, then, is one of many *tirailleurs sénégalais* conscripted to fight for the French forces over the twentieth century, eventually comprising a not-insignificant proportion of their militaries during the Indochina War—a population deracinated from home, granted tenuous, partial citizenship in exchange for physical vulnerability, and readily abandoned at the whims of the state.

A few moments later, Waly insists to Lan, "We belong to the same side. That of the subjugated." His words recall the vigorous, urgent rhetoric of Third World solidarity. The Third World, as succinctly described in the well-known formulation of Vijay Prashad, was never so much a "place" but rather "a project"—one of anti-imperialism, with emphatically internationalist dimensions.[2] Its history reveals not only its defeat but also its fissuring at the granular level. The "imagined communities" of anticolonial struggle rub up against the everyday reality—albeit here fictionalized—of the household or the interpersonal, with all their glittering dramas.[3] Idealized forms

of a "common context of struggle," as Chandra Talpade Mohanty emphasizes in her account of Third World feminism, though necessary, often dissolve in the hierarchical (and, especially, gendered) antagonisms of the nuclear family.[4] In relation to the imperial might and colonial history of France, Waly and Lan share a comradeship on the basis of their common oppression. Yet, in relation to one another—in the at once tiny, cosmic unit of the couple form—they are on opposite sides, a gulf between them.

The chasms between two people can sometimes find form in a third individual: a child. *Specter* emerges from Nguyen's collaborations with many such children—the families Diouf, Gomis, Ndoye, Gueye, Sarr, Doucouré, Thiaw, Seck, Coly, Lame, and Ndiaye—all of whom came together to explore the history of Vietnamese-Senegalese communities, primarily through personal stories of their own ancestors.[5] The work's genesis in this slow, collective endeavor frustrates both contemporary art's rapacious hunger for "the global" as well as its cathexis to "identity." *Specter* articulates the specific situatedness of Vietnam as a symbolic pawn and exemplary site of proxy conflicts in Cold War struggles, a region "torn between alignment and non-alignment."[6] It explores the consequences of that rivening as it played out in the lives of real individuals, but by fictive rather than straightforwardly documentary means. The work, therefore, conjures not only Third World solidarity in general but also the formulation "Afro-Asian," in particular. This term, with its roots in political projects of anti-imperial solidarity, must today resist easy conscription into a fashionable buzzword and ensuing weakening of its world-reshaping power.[7] Nguyen's work asks: What aesthetic forms would be adequate for the task?

Unlike other artistic predecessors and contemporaries, Nguyen does not approach the violent histories of colonialism and empire with the scalpels of dry documentation, the archival presentation of charts, images, and texts on walls or vitrines, nor does he play into the misty idea that "the larger the grain the better the politics."[8] In this latter formulation—put to words by filmmaker Trinh T. Minh-ha—impoverished media formats and obsolescent

technologies act as ciphers for the "real" and, in so doing, can meet a colonial demand for racialized "authenticity."[9] Rather than refuse the gratifications (and well-known hazards) of visual pleasure, Nguyen dives in headfirst, accepting the risks and plunging his audiences into the painterly, sensuous possibilities of narrative film in lush, high-quality digital formats and the imaginative possibilities of the speculative register.

Attempts to do right by the complex histories marshaled in Nguyen's oeuvre can sometimes result, inadvertently, in a disservice to the work itself: accounts of its content take precedence over its form.[10] Working in multichannel video, Nguyen both invokes the feature-length film, perhaps the most hegemonic art of the twentieth century, just as he frustrates its conventions. The period in which *Specter* is set is both the peak of Afro-Asian political activity and the apex of cinema as a globally dominant aesthetic form.[11] Yet, Nguyen crafts neither romanticized visions of solidarity and heroic revolutionary action nor misty-eyed, sentimental fantasies in which individualized narratives of "love" triumph over difference or distance.

If film produces its magic not only through the temporal dimensions of its unfolding narrative but also, since the late 1920s, through the miraculous synchronization of sound and image, *Specter* pressurizes such expectations. In lieu of durational unfolding, and with it, the satisfactions of "plot" and characterological reveal, Nguyen spatializes cinema, with multiple channels of video that abut and abrade one another in their gallery installation. Moreover, in *Specter*, as in his other works, utterances—both enacted dialogue and extradiegetic voiceovers or music—are often cleaved from the proper body of an anticipated "speaker." These two formal operations, spatialized multichannel installation and disarticulated narrators, ramify when joined together, creating a dizzying mise en abyme of visual and sonic effects.

In *Specter,* both sides of the conversation between Waly and Lan are voiced in the honeyed French of Anne-Marie Niane, whose face

we see in profile, lips inches from a crimson recording studio's pop shield and microphone. Niane is the author of their words *and* their narrator. The viewer also watches the mouths of Carmen Berry and Ibrahima M.F. Ndiaye shape the same syllables—although one cannot hear the voices resounding in the Saigon apartment. One screen keeps its gaze trained on Niane, another on the actors portraying Lan and Waly. Rounding out the installation, two additional screens swap their roles, sometimes showing black-and-white archival footage of African *tirailleurs* standing before Vietnamese children wearing conical hats or lining up before imperious white Frenchmen in ridiculous uniformed shorts. In other moments, the second and fourth screens may show a woman holding a photograph before her chest, an image, the viewer intuits, that perhaps captures the *real* Lan.

Many non-Francophone members of the audience will find themselves needing not only to toggle between the sounds of the words as they are enunciated by Niane and shaped by the mouths of Barry and Ndiaye but also to negotiate the script's translation into English (but, notably, not all languages) via subtitles on the lower third of the screen. At the 2019 Sharjah Biennial (for which the video installation was initially commissioned), viewers encountered each of the four screens as something like walls, partially stuck into the sand—history as ruin or shipwreck. In any of the multifarious installations of the work, the undulating connections appearing both synchronically across the four screens and diachronically across the unfolding scenes keep audiences only partially omniscient about the relationships construed between its protagonists.

Specter follows a loose three-act structure: after Waly and Lan is another speculative encounter, between Ibra and Madou (written by Macodou Ndiaye), then one between Maam and Fatima (by Merry Bèye Diouf). The work as a whole begins with a letter (read aloud by Ndiaye) and features other interludes between the dialogue-based scenes—a song performed a capella by Jean Gomis, and another song by Noreyni Seck. Where the conversation between Waly and Lan plunges us into the heart of the domestic, the kitchen, the tense

exchange of the second scene, between Ibra and Madou, takes place in public, in an office.

Once again, the viewer is not immediately provided clear context for the two speakers' relationship to one another, but rather dropped *in medias res* into their conversation with all its sedimented history. Their exchange—taking place across an enormous tank-style desk that highlights the distance between them—hinges on the excavation of a buried proper name, Nguyen Thi. Madou, upon discovering it is the name of his biological mother, has given it to his daughter, who, at two years old, remains unmet by her grandfather, Ibra. Nguyen Thi's name was found in a drawer, and, perhaps mirroring Madou's fictional discovery of it, the audience must link these histories through implicit suggestion—the connections are a delicate paper-chain she must privately and laboriously craft. She may be reminded of the opening salvo featuring Ndiaye (for whom Madou is a cipher) reading a letter from the *actual* Nguyen Thi, in which she recounts her longing for him and her love for her son, the real Ndiaye. The letter, as a family document, thus reappears in the imagined exchange between Ibra and Madou. Between his recitation of the letter and the invented words between himself and his father are a series of misrecognitions and impossible speech acts, with Ndiaye, like Niane before him, enunciating both parts.

The final act, featuring Maam and Fatima, is the most complex with regard to time and memory. It begins by establishing Maam as the grandmother of Fatima and with a scene of care: Fatima gently combs her grandmother's long hair. The performers playing Maam and Fatima mouth the words not only in the diegetic scene of their exchange but also, on other screens, alone and facing the camera, meeting its gaze. A third performer intrudes, wearing a turquoise *áo dài*—perhaps the younger version of Maam (p. 153). Their dialogue is a poetic exchange articulated through a series of imperatives ("I want you to remember, so that I can forget") and interrogative questions ("Do you remember the future?") that blur the lines of who is speaking and from when. Alongside the archival photographs, letters, and film footage scattered across the four channels, these

three scenes would seem to function like the "reenactments" of historical events common to documentary film. Of course, the scenes in *Specter* are not properly "reenactments" at all; rather, they are fictionalized renderings of exchanges that never took place. They are longing given form.

The three scenes of Nguyen's *Specter* are, instead, something more like "acting out," with all its myriad connotations in the English idiom, not only of practiced artifice ("acting out a scene") but also a distressed, emotional response to one's surrounding conditions—a mode of inarticulate dissent. The emphatically scripted nature of these exchanges is bookended by such paratextual devices as reading the scene heading aloud. These formal choices highlight the charged relationship between imagination, fantasy, and what, in 2004, Hal Foster identified within contemporary art's "archival impulse" as a "desire to turn belatedness into becomingness."[12] Where Foster's primary examples were the European and American artists Thomas Hirschhorn, Tacita Dean, and Sam Durant, we might here reorient, framing the speculative as a particularly useful device for the anticolonial artist—not least for the ways it can disrupt what anthropologist Johannes Fabian once criticized as the "transposition of real geographic distance for imagined temporal distance" that makes historicity and contemporaneity a distinctive problem for the so-called "non-West."[13]

Confounding the racialized expectations for truth and legibility at every turn, Nguyen's work finds fellow travelers in a larger cinematic lineage—albeit those that have often found more comfortable homes and receptive audiences in the white cube gallery or the biennial than the multiplex. This milieu encompasses the emergence of Third Cinema in Latin America in the late '60s, alongside other comrades such as the Black Audio Film Collective and the Otolith Group.[14] Erica Balsom and Hila Peleg have recently defined this mode of nonfictional cinematic "worldmaking," following Amia Srinivasan, as "a nonhegemonic mode of archive-based historiography that aspires toward the transformational potential of documentary representation as opposed to the theoretical

construction of the fictional and the illusionistic 'real' within the diegetic space."[15] This is an approach that not only "redescri[bes] reality" but also "rejects the authority of received frameworks of intelligibility."[16]

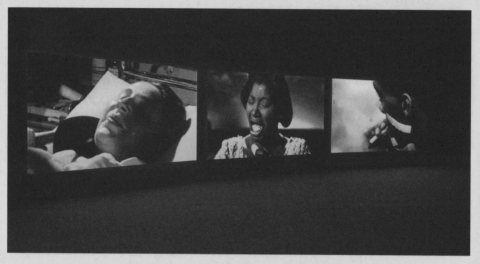

John Akomfrah, *The Unfinished Conversation*, 2012. Three-channel HD video installation, 7.1 sound, color; 45:48 min. Installation view: "John Akomfrah: Signs of Empire," New Museum, New York, June 20–September 2, 2018. Courtesy Smoking Dog Films and Lisson Gallery

I emphasize these connections with a wide array of traditions and sources purposefully, to push against the geographic or biographical essentialism that would issue solely from comparing the work of Nguyen and that of Trinh, though few have skewered the desire for exoticized "Other" in registers both cinematic and ethnographic as deftly as she. Already in her 1986 essay "Outside In Inside Out," Trinh pushed against the conventions of ethnographic documentary film practices, opposing the clamor for authenticity via its "string-of-interviews style and the talking heads, oral-witnessing strategy"—which, she noted disapprovingly, is "often called 'giving voice,'" despite acting only as "devices of legitimation" for the filmmaker, serving a compensatory function for a true equity that can never arrive.[17]

Other reference points abound. As Nguyen has observed, the speculative register of Octavia Butler's 1979 novel *Kindred* was

formative during his student days.[18] (Butler's protagonist, Dana, is shunted between her own Los Angeles of 1976 and a Maryland plantation in 1815.) In the unexpected syntax of Nguyen's title, *The Specter of Ancestors Becoming,* might we hear not only the resonances of Butler's fiction but also an adjacency with (but certainly not a duplication of) Saidiya V. Hartman's scholarly method of critical fabulation.[19] Relevant, too, is the artist's time studying with Daniel Joseph Martinez, perhaps best known for his work at the polarizing 1993 Whitney Biennial, in which he redesigned the museum's metal admission tags—to be clipped onto a lapel upon entry, visibly signaling that one had paid admission to the museum—replacing the existing text, "WMAA," with fragments of the phrase, "I CAN'T IMAGINE EVER WANTING TO BE WHITE."

Though the biennial itself received caustic criticism on the grounds of its engagement with issues of race, gender, and sexuality and was often maligned as being unnecessarily reductive, this piece, as Michael Ned Holte has identified, was profoundly *anti*-didactic, despite being cast as such.[20] By cleaving the syntactical logic of the phrase and distributing its pieces unequally among exhibition visitors and museum workers alike, the question of "identification" and even the structure of "race" as they are connected to unconscious desire and imagination were revealed to be contradictory and illogical—powerful, precisely because impossible to explain.

Just as placing Nguyen's practice alongside that of artistic fellow travelers helps to elucidate the stakes of his aesthetic project, we can also look to other work by Nguyen to understand more fully how it has preoccupied itself with the dangers of conventional narration—especially the testimony of the racially dispossessed subject. Though Nguyen's oeuvre typically focuses on the Vietnamese diaspora and its geopolitical entanglements with other regions, there are two exceptions: *We Were Lost in Our Country* (2019; p. 111–17) and *Crimes of Solidarity / Crimes de solidarité* (2020; p. 119–25). Both works highlight petitions to the government: the first focusing on Indigenous Australians' fight for land sovereignty through the Native Title Act, and the second on migrants from Africa to France, former

tenants of Squat Saint-Just in Marseille.[21] Both films demonstrate how such speech acts might be performative—in the technical sense of having a capacity "to do things" or enact change in the world—but because they must hew to the conventions and expectations of their colonial auditors, they are hardly felicitous.

Three further devices reverberate, both in *Specter* and across Nguyen's earlier oeuvre: ventriloquism, animacy, and repertoire. The first of these, taken in a more capacious register than the creepy vaudevillian act, acknowledges that, as the cultural historian Steven Connor writes, any given voice is "not a condition, nor yet an attribute, but an event."[22] Because the normatively-abled speaker is also always already an auditor, unavoidably hearing herself in the same moment she enunciates, "the voice always requires and requisitions space," creating a distance, Connor writes, "that allows [one's] voice to go from and return to [oneself]."[23] Sound is a peculiar sense, he helps us to understand—it is often "experienced as enigmatic or anxiously incomplete until its source can be identified," and in the case of cinema, audiences have been subtly disciplined to expect the "visual verification of seeing a moving mouth at the very moment of its sonic utterance in order to manage the magic or scandal of an unattributed voice."[24]

Nguyen often delves directly into this magic or scandal, not only by divorcing the visual confirmation of speech from its audible source (here "ventriloquism") but also by "giving voice" to the speaking dead, the speaking animal, or the speaking object, reanimating what has been excluded from the realm of language. This prioritizing of nonhuman "animacy" appears most explicitly in *My Ailing Beliefs Can Cure Your Wretched Desires* (2017; p. 81–91) and *The Sounds of Cannons, Familiar like Sad Refrains / Đại Bác Nghe Quen Như Câu Dạo Buồn* (2021; p. 181–89). The first is narrated by a snarling, caustic voice who identifies himself as Last Javan Rhinoceros in Vietnam, seen only as a skeletal mount in a museum. He rages against his own extinction and that of animal-kind as a consequence of the market for exotic animal substances as culinary delicacies and ostensible curatives alike. Soon it becomes clear that the rhino

is not addressing the audience, but rather a specific interlocutor, another animal, "Madame Turtle"—and that theirs is a Socratic dialogue of political options. The turtle is more circumspect about an animal revolution, which the rhinoceros sees as a necessary corollary to human anticolonial struggle.

In *The Sounds of Cannons*, the speaker is, on the one hand, an ostensibly "inanimate" object, but notably, one with the greatest capacity to "act upon" other beings in the world—an unexploded ordnance (or UXO) in Quảng Trị (one of the most heavily shelled areas during the Vietnam War). Across the work's two channels appear, on the left, jingoistic propaganda by the US military, and on the right, the careful labors of a team of experts dedicated to safely disarming the bomb (p. 213). "They found me," the bomb says, narrating the human's attempt "to defuse [it], to take [its] insides" as something more like surgery or violence. The speaking ordnance queries an unknowable possibility—whether US soldiers occasionally elected *not* to trigger the contact fuse as a material attempt to register their disapproval of the war. Is the bomb's presence an act of sabotage "or just a malfunction?" The narrator then turns introspective: "Am I just a failure?" As if to make clear the very real power of objects, the video concludes with its (safe, coordinated-by-experts) detonation. At the climax of the explosion, the melody of Trịnh Công Sơn's pop song, as sung by Khánh Ly—from which the work's title is taken—rings out: the English translation of the Vietnamese lyric "the flesh and bones of our mothers and children" crawls along the video's bottom edge just as hundreds of tons of earth arc terribly into the sky.

Mel Y. Chen describes how languages both impose and reflect hierarchies of animacy that separate the living "human" from either the dead or the nonhuman object or animal; so, too, does language affirm unequal valuations embedded in the ascriptive categories of race, gender, and ability.[25] We see the slippery conduit between racialized subhuman and animal nowhere more clearly than in a brief scene in *The Boat People* (2020; p. 101–09), in which a group of children passes by an abandoned jail cell marked "Monkeyhouse,"

but clearly intended for humans (a viewer familiar with Nguyen's oeuvre as a whole will find this brief flash consonant with the rhinoceros's argument in *My Ailing Beliefs*). These ideas reappear in *The Unburied Sounds of a Troubled Horizon* (2022; p. 191–225), which makes its investment in human reincarnation explicit.

In rejecting the conventional Western hierarchies of animacy—by letting a bomb, rhinoceros skeleton, or the partially buried deity statue, severed from body, who comes "to life" in *The Boat People* speak—Nguyen avoids turning these newly garrulous subjects into spirits with divine omnipotence or narratological omniscience. Instead, they are often vulnerable, and like the speech of people, theirs is liable to stutter and second-guess. The speaking statue in *The Boat People* attempts to define a "god" to her young interlocutor, Nguyệt, this way: "Humans invented, or rather, should I say, put a name to that force." In interrupting herself to rephrase, she reveals not only her own limited and situated knowledge but also the inability of language to capture adequately the nonhuman forces to which she refers.

The simultaneous vulnerability and persistence reappear in Nguyen's keen attention to physical repertoires of music and dance. This sense of especially embodied affective transmission is highlighted by Nguyen's cinematography and directorial eye. No doubt it, in part, issues from the artist's previous experiences in commercial film and, especially, time spent making music videos. As he notes, in the music video format, "no matter whom you're shooting, you have to make them look like they're the most important person in the world."[26] The crisp, sometimes dizzying tracking shots and hypnotic Steadicam swirling through space give proper importance to Nguyen's protagonists, but also parry international (read: so-called "Western") art audiences' desire for the atemporal "authenticity" of the Global South. In *My Ailing Beliefs,* for example, this finds its fullest effects in the woozy movement of the two-channel installation, where the vertiginous images of each sometimes seem to spill into the seam where the two screens meet, and the rhinoceros's words rhythmically track a song by NVM.

Nguyen worked with cinematographer Andrew Yuyi Truong in *Specter,* with additional camera work by Allison Nakamura; the work's four screens highlight acrobatic camerawork and slow-motion footage. This is especially effective in the scenes of Ndiaye and others performing Vovinam or Việt Võ Đạo, a Vietnamese martial art.[27] In the figures' entwining limbs and movements through space, the viewer sees what scholar Diana Taylor has called "repertoire," the often devalued forms of cultural memory that require oral tradition and body-to-body transmission.[28]

Though this period (2017 to present) of Nguyen's artistic practice may be readily described as that of his "solo" work, it seems more correct to see in these films a continuation of the collaborative impulses animating his time in The Propeller Group. These are works made, profoundly, in *collaboration,* with all its antagonisms and asymmetries, across time and geography. In a recent conversation with Vivian Hui, the artist has conceded that he does not "subscribe to the idea that repair is an option within a post-colonial context."[29] The symbolic acts of speech, cinema, and art can neither reconstruct what has been lost nor mend what has been harmed. Yet, caught in the throat between one voice and another, in the real-time exchange of bodies in space and the transmission of memory, they might, nevertheless, highlight the foreclosures of common language and gainsay the colonial infrastructures it simultaneously obscures and upholds.

1 In 1957, the ship's ownership was transferred to North German Lloyd, and her name changed to *Bremen* following a major rebuild.

2 See Vijay Prashad, *The Darker Nations: A People's History of the Third World* (New York: New Press, 2008), xv.

3 See Benedict Anderson, *Imagined Communities* (London: Verso, 1983), and the uptake of this term in anticolonial and Third World contexts.

4 Chandra Talpade Mohanty, "Cartographies of Struggle: Third World Women and the Politics of Feminism" (1991), in *Feminism without Borders: Decolonizing Theory, Practicing Solidarity* (Durham, NC: Duke University Press, 2003), 43–84.

5 See Tuan Andrew Nguyen, *The Specter of Ancestors Becoming* (Dakar: RAW Material Company, 2022).

6 Christopher E. Goscha and Christian F. Ostermann, "Introduction," in *Connecting Histories: Decolonization and the Cold War in Southeast Asia*, ed. Christopher E. Goscha and Christian F. Ostermann (Stanford, CA: Stanford University Press, 2009), 5.

7 See Rasheed Araeen, *The Other Story: Afro-Asian Artists in Post-war Britain* (London: Hayward Gallery, 1989); the forthcoming book by Joan Kee, *Geometries of Afro-Asia: Art Beyond Solidarity* (Berkeley: University of California Press, 2023); and Fred Wei-han Ho and Bill Mullen, *Afro-Asia: Revolutionary Political and Cultural Connections between African Americans and Asian Americans* (Durham, NC: Duke University Press, 2008). For a discussion of "internationalism" as a framework for art history in lieu of the "global turn," see Chelsea Haines and Gemma Sharpe, "Art, Institutions, and Internationalism, 1945–1973: Introduction," *ARTMargins* 8, no. 2 (2019): 3–14.

8 Trinh T. Minh-ha, "Outside In Inside Out" (1986), in *When the Moon Waxes Red: Representation, Gender and Cultural Politics* (London and New York: Routledge, 1991), 71.

9 Coco Fusco, "The Other History of Intercultural Performance," *TDR* 38, no. 1 (Spring 1994): 143–67. See Erika Balsom on the ways that celluloid's appearance in the white cube is "aligned with preciousness and rarity . . . closely linked to disappearance, the historical trace, and the failed utopia." Erika Balsom, "Filmic Ruins," in *Exhibiting Cinema in Contemporary Art* (Amsterdam: Amsterdam University Press, 2013), 101.

10 See Joan Kee, "Introduction: Contemporary Southeast Asian Art: The Right Kind of Trouble," *Third Text* 25, no. 4 (July 2011): 371–81.

11 Histories of the Afro-Asian often center on the well-known 1955 Asian-African (or "Afro-Asian") Bandung conference, held in the Indonesian capital and featuring representatives of twenty-nine Asian and African nations. Later, these found especially artistic and literary dimensions in the many Bandung-inspired gatherings, collectively known as the Afro-Asian Writers' conferences, and their attendant publication arm, Lotus, among other journals. The Afro-Asian Writers' conferences were held first in Tashkent, Uzbekistan (then Uzbek SSR) in October 1958, with later iterations in Cairo, Egypt; Beirut, Lebanon; New Delhi, India; Almaty, Kazakhstan (then Kazakh SSR); and, in 1979, Luanda, Angola. To this internationalist history of artistic gatherings, we might also note the important First World Festival of Negro Arts, initiated by Senegalese president Léopold Sédar Senghor and held in April 1966 in Dakar (followed by FESTAC '77 in Lagos). Though Bandung acts like a lodestar in the writing of these histories, the political project of the 1955 conference emerged from an earlier groundswell of activity. See Cindy Ewing, "The Third World Before Afro-Asia," in *Inventing the Third World: In Search of Freedom for the Postwar Global South*, ed. Gyan Prakash and Jeremy Adelman (London: Bloomsbury, 2022), 29–44.

12 Hal Foster, "An Archival Impulse," *October* 110 (Fall 2004): 22.

13 Johannes Fabian, *Time and the Other: How Anthropology Makes Its Object* (New York: Columbia University Press, 1983). For a few discussions of this dynamic art-historically, see Partha Mitter, "Decentering Modernism: Art History and Avant-Garde from the Periphery," *Art Bulletin* 90, no. 4 (December 2008): 531–48; Prita Meier, "Authenticity and Its Modernist Discontents: The Colonial Encounter and African and Middle Eastern Art History," *Arab Studies Journal* 18, no. 1 (2010): 13–46; and Salah M. Hassan, "African Modernism: Beyond Alternative Modernities Discourse," *South Atlantic Quarterly* 109, no. 3 (Summer 2010): 451–74.

14 See Fernando Solanas and Octavio Getino, "Toward a Third Cinema," *Tricontinental*, no. 14 (October 1969): 107–32. The Black Audio Film Collective coalesced in Hackney in 1982 (John Akomfrah, Reece Auguiste, Edward George, Lina Gopaul, Avril Johnson, David Lawson, and Trevor Mathison); the Otolith Group in London in 2002 (Anjalika Sagar and Kodwo Eshun).

15 Erika Balsom and Hila Peleg, "Introduction: No Master Territories," in *Feminist Worldmaking and the Moving Image*, ed. Erika Balsom and Hila Peleg (Cambridge, MA: MIT Press, 2022), 23–24.

16 Balsom and Peleg, "Introduction," 23–24. Notably, Balsom and Peleg's essay title is drawn from Trinh T. Minh-ha.

17 Trinh, "Outside In Inside Out," 67.

18 See Tuan Andrew Nguyen, "The Art We Love," *Artforum* 61, no. 1 (September 2022), 239.

19 See Saidiya V. Hartman, "Venus in Two Acts," *Small Axe* 12, no. 2 (June 2008): 1–14.

20 See Michael Ned Holte, "Change Agent: The Art of Daniel Joseph Martinez," *Artforum* 55, no. 3 (November 2016), 243–44, 246–49.

21 The former combines archival footage of the making of the Ngurrara Canvas II (part of a campaign to achieve formal recognition for their land sovereignty through the Native Title Act) in the late 1990s with contemporary conversations, twenty years later, with these Indigenous Australian communities—many of which are the direct descendants of the original painters. *Crimes of Solidarity* features the former tenants of Squat Saint-Just in Marseille, created in 2018 to provide shelter for up to three hundred undocumented migrants. The monologues of each speaker featured in *Crimes* are performances typically intended for an audience of administrative bureaucrats, but in the work are made available to global consumers of contemporary art, commissioned for Manifesta 13.

22 Steven Connor, *Dumbstruck: A Cultural History of Ventriloquism* (Oxford, UK: Oxford University Press, 2001), 4.

23 Connor, *Dumbstruck*, 5.

24 Connor, *Dumbstruck*, 20.

25 Mel Y. Chen, *Animacies: Biopolitics, Racial Mattering, and Queer Affect* (Durham, NC: Duke University Press, 2012).

26 Tuan Andrew Nguyen, "At the Edge Of: Tuan Andrew Nguyen in Conversation with Rahel Aima," *Mousse*, October 13, 2020, https://www.moussemagazine.it/magazine/tuan-andrew-nguyen-rahel-aima-2020.

27 See Merry Beye Diouf, "Vovinam Việt Võ Đạo in Vietnamese History," in *The Specter of Ancestors Becoming*, 94–98.

28 Diana Taylor, *The Archive and the Repertoire: Performing Cultural Memory in the Americas* (Durham, NC: Duke University Press, 2003).

29 Tuan Andrew Nguyen, "Tuan Andrew Nguyen: The Limits of Narrative: In Conversation with Vivian Hui," *Ocula*, April 17, 2020, https://ocula.com/magazine/conversations/tuan-andrew-nguyen/.

Shrines Instead of Cathedrals

—

Christopher Myers

In Chợ Lớn, a neighborhood as intricate as lace, hundreds of store-fronts crowd each other, overflowing with bolts of fabric, the excess material of everything "made in Vietnam," a traffic jam of cottons, polyesters, and silks. In each shop, there is a shrine, attached to the rafters or tucked in a corner on the floor—a small wooden box stained a dark red-brown. There are brass sculptures of deities and tiny pink forests of ashen incense sticks, pomelos and bananas, an occasional glass of brown liquid. Black-and-white photos curl around images of absent loved ones, stray cigarettes they would have smoked, favorite candies, a watch that stopped telling the time long ago, a bouquet of two-dollar bills from the United States. There are shrines like this everywhere in Vietnam, in department stores and banks, airline offices, motorbike repair shops, restau-rants, bookshelves, kitchens, homes. There are shrines like this in my childhood as well, a collection of artifacts in a corner of my Nigerian auntie's kitchen, Dominican neighbors with an old machete and bottles of rum, beside the microwave, a small copper house festooned with silk marigolds hiding a plaster god in dayglow colors, a hallway closet with candles and honey and pennies.

I imagine all these shrines, in Saigon, in Ife, in Salvador, in the Bronx, in Kerala, a holy city in miniature; this vast collectivity of altars, a metropolis of prayers and memories and hopes. As if God couldn't bear to exist in any singular place, as if the process of diaspora, of making homes in the corners of other people's houses, was the clearest path to all that is holy. The architecture of each tiny house is a doorway to the transcendent, overarching, sublime, and in the same breath, as intimate as lips caressing the mouth of a bottle or the sweetness of countless hands tending, dusting, refilling these refracted churches.

But it is important to note that these are not cathedrals. Their narra-tives do not seek to overpower. There is no aspiration to orthodoxy. The materials are often quotidian, impermanent, even cheap. The function is served more by the pungent softening of overripe fruit, a malleable catechism, than by any such dogmatic material like marble—calcified, inaccessible, and alienated. Where temples

aspire to timelessness, an infinity born of erasures, amnesias, and displacements, these personal shrines wield their power in the idiosyncratic and the specific, in winding streams of memory, at once ephemeral and enduring.

The Notre-Dame Cathedral Basilica of Saigon, a gothic freighter of a building, lays anchor in District 1 of Ho Chi Minh City. The red stones of the building were shipped in from Toulouse, the statue of Mary in front carved from Italian marble. It is part of a jewel box of colonial architectures downtown. An opera house, a post office, some administrative buildings all stand in contrast to the ad hoc shrines in every home and shop. The architectural forms imported from the metropole to the outpost, cultural and religious centers and prisons, engage

in fantasies of access to God or the state or the distinct lack thereof. Currently, there are several layers of fence and metal detectors cordoning off the cathedral from all but the most devout of worshippers.

There is a magic to all this imported stone, the weight of it—a kind of opposite magic to the improvisation and everyday nature of the shrines. The turrets, thick as the walls of Côn Đảo Prison, imitate the cathedral of the same name in Paris, pretend to be immutable, as constant as the vigilance of that same colonial God who accompanied Portuguese missionaries, piling their alphabet on the tongues of the Vietnamese people. Where the shrines are integrated into commerce and cooking, the cathedral is an event, separate from all praxis. Where the shrines live in memory and time, responsive and inviting in the way of old friends reminiscing about loved ones, the cathedral lives in a place outside of time; its imitation permanence, faux timelessness, hiding the erasure that is the hallmark and weapon of colonialism—or, for that matter, patriarchy, heteronormativity . . .

Domination is an inherently amnesiac form. The colonials, the modernists, the prison builders, the missionaries all engage in the most aggressive forms of forgetting. In the neighborhoods where I grew up, sometimes boys with split-level haircuts and girls with gold teeth would say, "Why you acting so 'brand new'?" Which is a hood way of saying, "Miss me with your pretension toward novelty; acknowledge that you have and come from a history as complicated and rich as mine." It is the same with artists sometimes—the ones who come from those dominant traditions, the ones who wish to build cathedrals, who revel in their simulacrum of newness, the illusion of their own novelty.

I am talking about all of this to trace the genealogy of an artist. All art has genealogy, has ancestors to the kinds of looking it invites, to the way we are asked to be in these spaces. When I think of Tuan Andrew Nguyen's work, this question of genealogy and ancestors comes to the fore.

Tuan's work, like so many of us, stands at the crossroads of various histories. Certainly, the bronze and marble men of video installation and sculpture lurk in the corners of his galleries. The self-mythologizing of Beuys and the lush aesthetics and cinematic eye of Pipilotti Rist or Bill Viola sing through the videos. The films of Wong Kar-Wai, Apichatpong Weerasethakul, Kidlat Tahimik, Ousmane Sembène, and contemporaries like Khalil Joseph and Mati Diop exist in a similar universe as Tuan's pieces. But if we are to imagine these works as shrines, instead of cathedrals, as agglomerative collections that serve to provide connective tissue between past and present, there are more ancestors to acknowledge.

Paris by Night is a video series on DVD sold in the kind of shops where Vietnamese-American teens, with uncreased Nikes or goth bangs or whatever poor fashion choice is popular amongst teenagers, roll their eyes as their parents grab dried squid, dried mushroom, and bánh hỏi. This is a ritual of diaspora—this trip to the supermarket, mirrored in botanicas, Patel Brothers, 99 Ranches, H Marts, and countless "African" shops. The shelves are packed with little bits of memory, smells from home, inconvenient conveniences, spice presses, hair dye, and newspapers. There are supplies for home shrines, incense sticks, joss paper, bundles of leaves, or wood. But, in some ways, the ethnic market itself is a gathering of objects in a similar vein, drawing lines between worlds, between histories, collapsing time—a visual representation of displacement and diaspora—like scar tissue, at once a sign of trauma, remembrance, and healing.

And like their counterparts—Nollywood films with lurid, lightning-inflected covers or Oliver Samuels stage plays taped in school gyms and reproduced endlessly—DVDs like *Paris by Night* speak from and to a diasporic collectivity. *Paris by Night* is filmed in various Vietnamese cultural hubs—originally Paris, but later California, Oklahoma, Minnesota, and Toronto. There are comedic skits and gowns and suits and the kind of longing tunes that every diaspora invents (the way that "Jamaica Farewell" becomes "Lời Yêu Thương," and both songs mean much the same thing). From time

to time, there is something overtly political in an episode or seven, but the primary function of these kinds of media is as part of an exchange.

The nature of shrines is that they are participatory. They need tending and enacting. They are a locus of discussion between a "here" and a "there." Similarly, media like *Paris by Night* is the product of a conversation between "home," as a near-fictional place that lives in the imagination of countless migrants, and the lived realities of these folks where they live. Like the shrines, like the supermarkets, *Paris by Night* is an accumulation, a memory machine that helps its viewers remember where they have been and where they are.

This form is one of the ancestors of Tuan's work: his videos are also conversations, participatory, accumulative. They are love letters to and from diaspora. The people in his films are understood through and in discussion with their histories. Their existence is the scar tissue of world events, colonialism, migration, war. All of our existences are like this—only cathedrals and colonialists imagine themselves outside of time, sprung fully formed from the earth like Athena from the brow of Zeus. But Tuan's vision of the world roots these resonances, sets right the drifting migrant ships, maps the oceans of history around them. Half essay, half dream, navigating our connections to the currents of time.

Time is strange in the global North. Sometimes it doesn't exist, like when we are told to "get over the past"; sometimes it exists too much, like when they sing anthems and print currency. Whichever strangeness is enacted, time is never connected, never intertwined with our present-day existence. For example, there are so many antique shops in Charleston, South Carolina—busy forgetting its history as an epicenter of the slave trade in the ornately carved wood of old furniture. By contrast, it is still difficult to find an antique shop in Nairobi. There are very few good old days to remember fondly. This is true of so many of our places. You can certainly find used goods, hand-me-downs that have a little more use left in them. But the combination of nostalgia and alienation that is necessary to make a proper antique shop is a harder equation. Nostalgia itself is a kind of alienation, the razor that cuts the cord of time, renders history curious, charming, and divorced from today.

In District 1, off Yersin Street, there is a market people call the "military surplus market." While the vast majority of things sold there are recently made—bags and pants made of crisp olive drab canvas or a fair amount of lighting supplies—the occasional stall or street corner seller hawks bits and bobs left over from the war. There is one man with a raft of scratched Zippo lighters balanced on a briefcase. This, too, is a kind of conversation with history, both the bootleg articles and the broken gauges from some ancient US war

machine. These places, too, do the work of inscribing time as a web, a network of connections that cannot be severed.

Tuan's sculptural work would fit well in one of these markets that, like the shrines, serves less to divorce one's present from one's past. The materials Tuan uses have had many lives. There is a suggestion that the work itself is just one iteration of these materials, that there may yet be others. The remnants of bombs left over from war slide into new forms, modernist sculptures, prayer bowls. Each form carrying with it some story of its former life, a cycle of reincarnation exemplified in brass and steel.

Tuan is like that himself—he's had too many lives, each one interdependent with the others, impossible to imagine separately. MFA programs and 7-Elevens, a Buddha in a nail salon, b-boying and boat people, guns and poems, *tirailleurs* and migrant camps. All of these things are intimately related to who Tuan is, who he has written himself to be. If you think of all these chapters as paragraphs, connected histories, an essay trying to wrangle all the worlds together, tie yesterday to today to tomorrow—the work is Tuan trying to justify the margins, to make it feel as elegant and straightforward as a shrine in the back of a fabric shop in Chợ Lớn.

Tôi Về (I Return)

—

Nghiêm Phái-Thư Linh

Đặng Thị Lạc, known as Nghiêm Phái-Thư Linh, the artist's grandmother, at her desk, ca. 1960

Từ buổi xa quê cát bụi mù
Lạc trong kỳ ảo của thiên thu
Đường dài thăm thẳm chân chồn mỏi
Sương quyện mơ hồ gió lạnh ru
Chỉ ngại lối xưa trăng huyễn hoặc
E rằng nẻo mới cảnh hoang vu
Tôi về tìm cái tôi còn, mất?
Thi hữu đừng chê khách viễn du.

Về tìm Tiên động Thanh - Hư
Trách sao rắc đoá tương tư xuống trần
Về mong hưởng lại hương xuân
Nghe muôn trùng vọng tiếng ngân tuyệt vời
Tôi về ngắm phiến mây trôi
Tìm trăng cổ độ, thăm người tri âm
Về nghe chuông sớm nhẹ ngân
Tìm trong ký ức tiếng thầm chân như
Về nghe điệu hát tình ru
Hay lời sông núi thiên thu dịu dàng
Tôi về ủ đoá ngọc lan
Vào trong tim nhỏ ngập tràn thương yêu
Về nghe ngâm đoạn chuyện KIỀU
Đắm hồn say tứ mỹ miều trong thơ
Tôi về dệt mộng ươm tơ
Tơ vàng thắm ý, mộng mơ ái hoà
Trời xuân rực rỡ muôn hoa
Hương sen thanh quý, hương trà nồng say
Nước non vẫn nước non này,
Dòng sông hồng ấp áng mây trắng hiền
Kính mời bạn tới thư viên
Mực xanh thơm, giấy hoa tiên sẵn chờ
Bên nhau nhắp cạn nguồn thơ
Cùng say chung hưởng trúc tơ tân kỳ.

From the time I left my homeland, amidst the dusty haze
Lost in the strange illusion of perpetuity
The endless road, even longer with my weary feet
The misty fog blends with the lullaby of the cold wind
Hesitant of the old route, mysterious under beguiling moonlight
Fearful of the new paths that lead to desolate territories
I return home to find the self that remains, the one gone?
Fellow poets, do not mock this distant traveler.

I return to seek out the nymph of Thanh Hư cave
To blame her for scattering the flower of longing onto the mortal world
I return, hoping to once again enjoy the scent of spring
To listen to the magnificent reverb of the infinite
I return to watch slabs of clouds drift by
Seeking the ancient moon, visiting kindred spirits
Returning to listen to the gentle, early morning bell toll
Seeking in my memory the whispering truth
Return to hear the lullaby of lovers
Or the soft words of the ageless mountains and rivers
I return to embrace the blooming magnolia
Into a little heart filled with love
Return to listen to recitations of "The Tale of Kiều"
To submerge the soul into the marvels of poetry
I return to weave dreams spun with silk threads
Golden silk soaked with thoughts, woven dreams in harmony
The vernal sky swims in seas of flowers
The precious fragrance of lotus, the divine aroma of tea
The land is what the land still is,
The pink river nurses tender white clouds
I invite you to come visit the haven of letters
Where scented blue ink and flower petal paper await
Together, savoring the fountain of poetry until the last drop
And be drunk on the mystical melodic tunes anew.

Translated by Lê Nghiêm Minh Trí, Tuan Andrew Nguyen, Tài Thy

*My Ailing Beliefs
Can Cure Your
Wretched Desires*,
2017

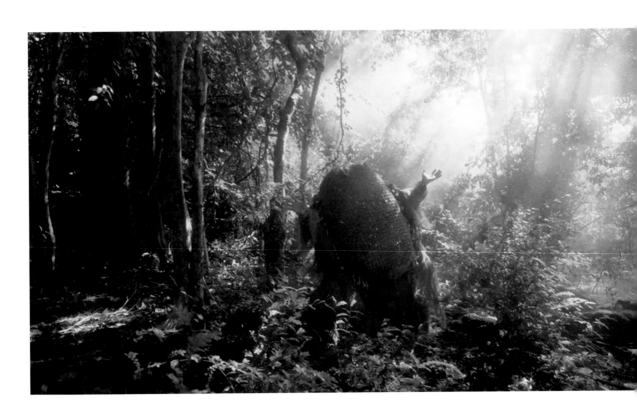

What were you before you

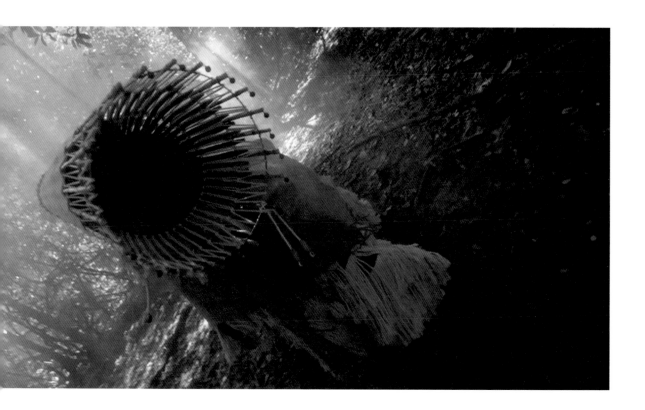

were reincarnated as a rhino?

There is a certain kind of violence

in the way they look at things…

Death before

extinction!

The desire for our horns, our scales, our

talons have become a human disease.

The Island, 2017

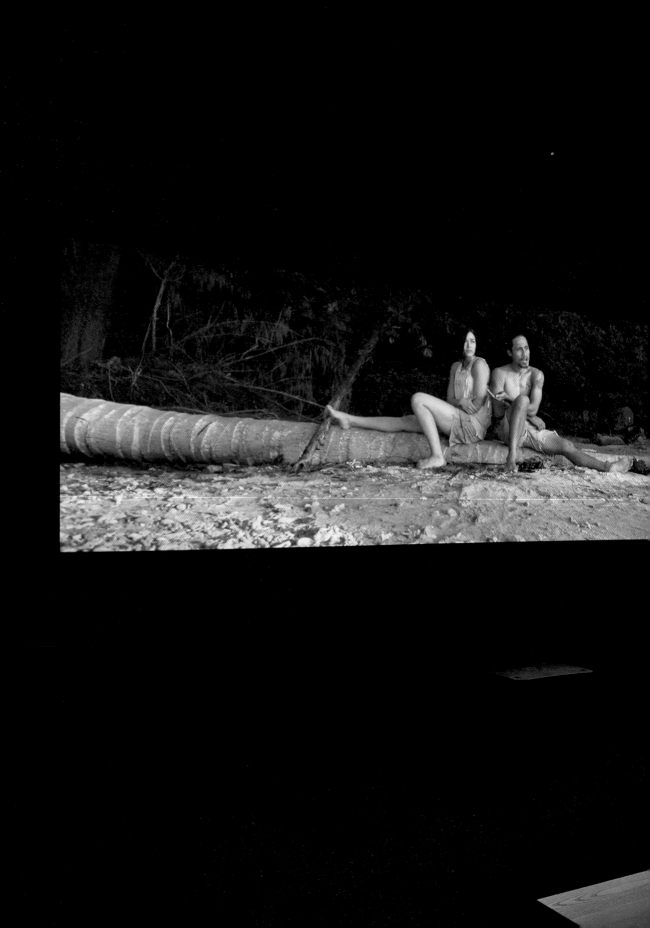

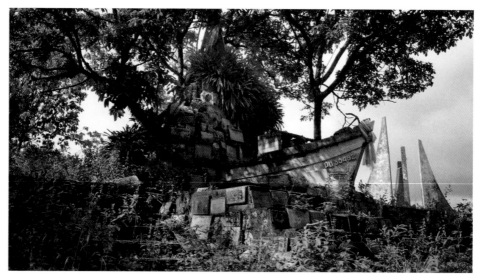

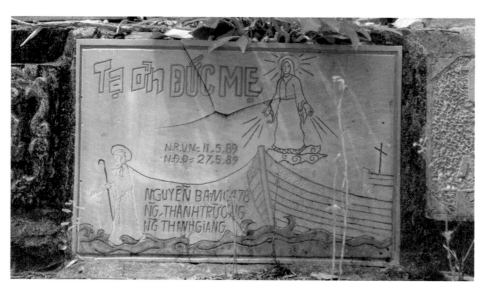

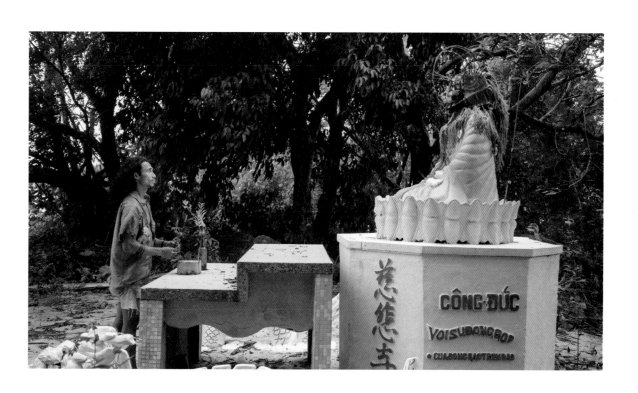

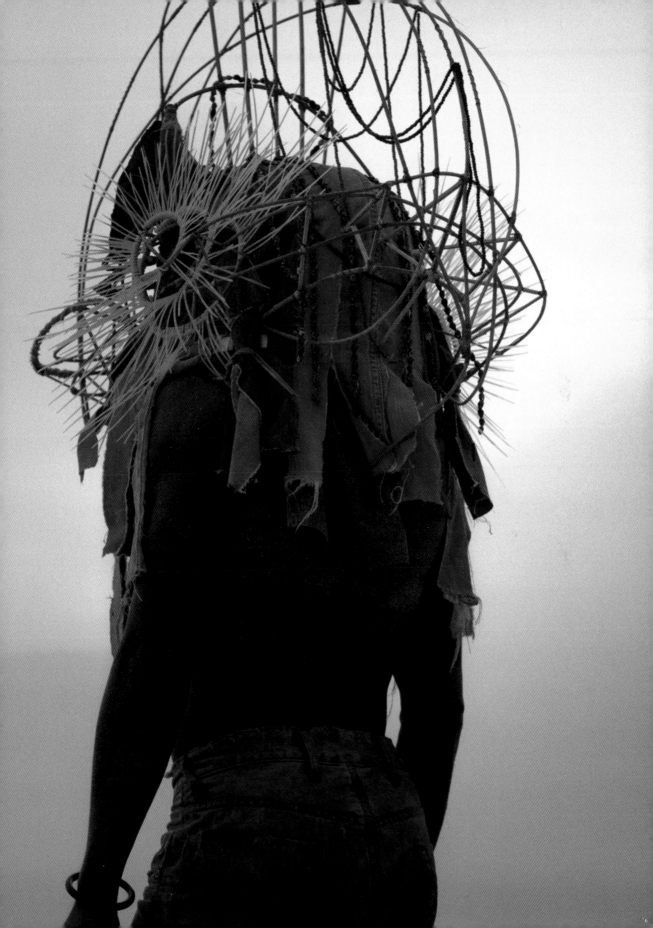

The Boat People, 2020

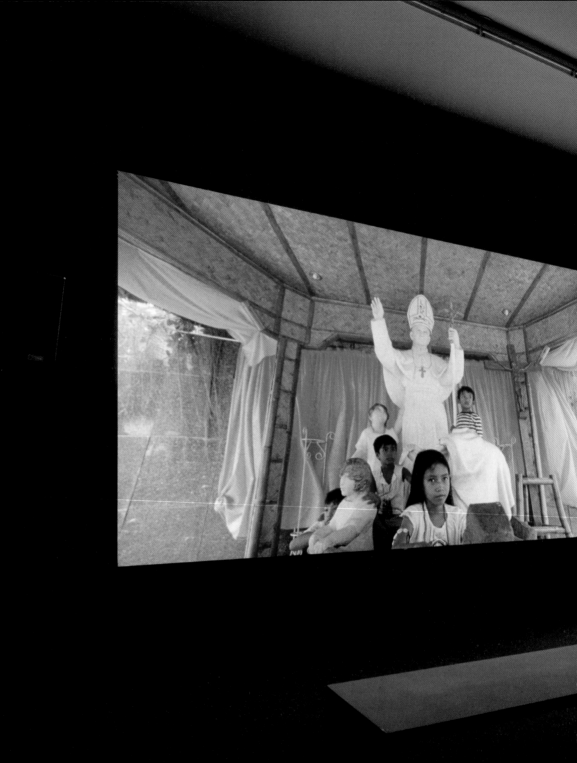

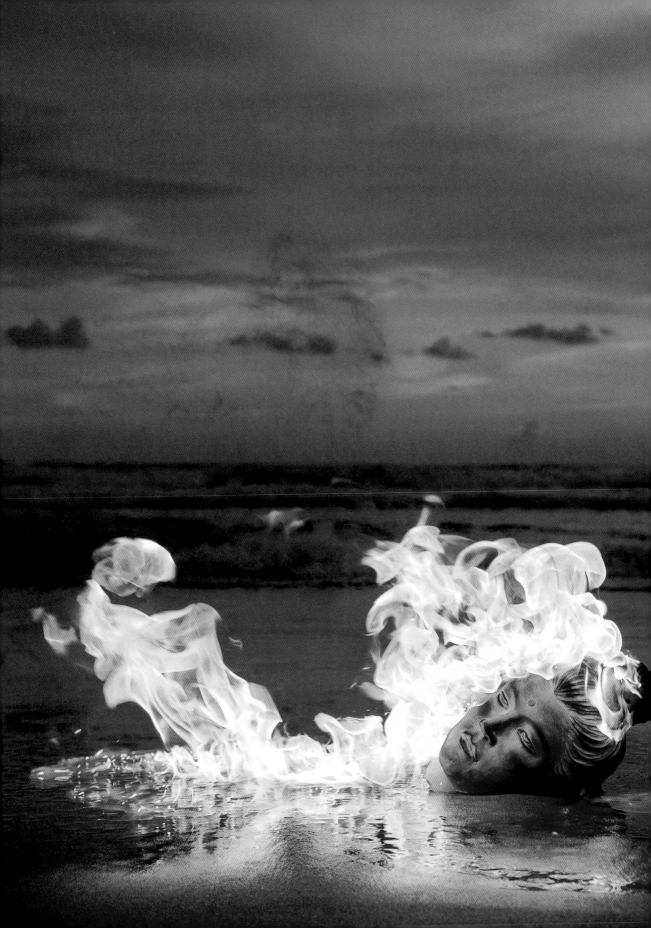

*We Were Lost
In Our Country*, 2019

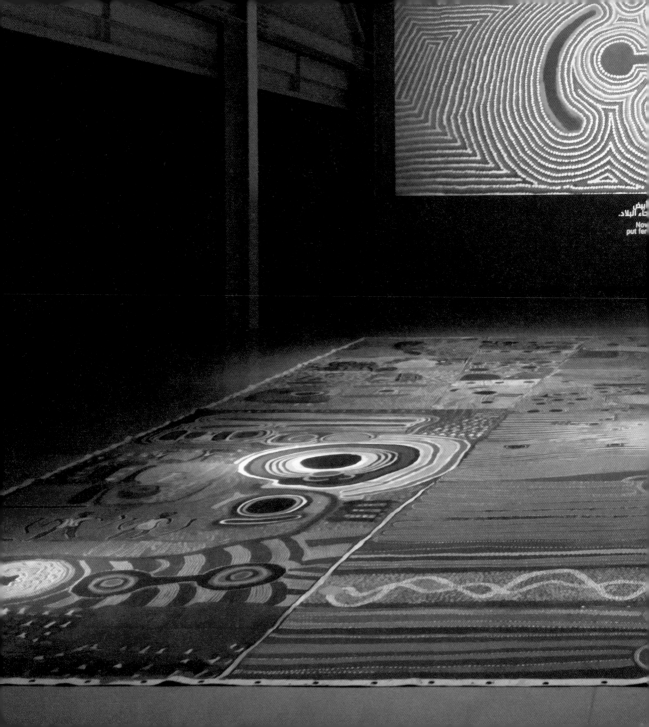

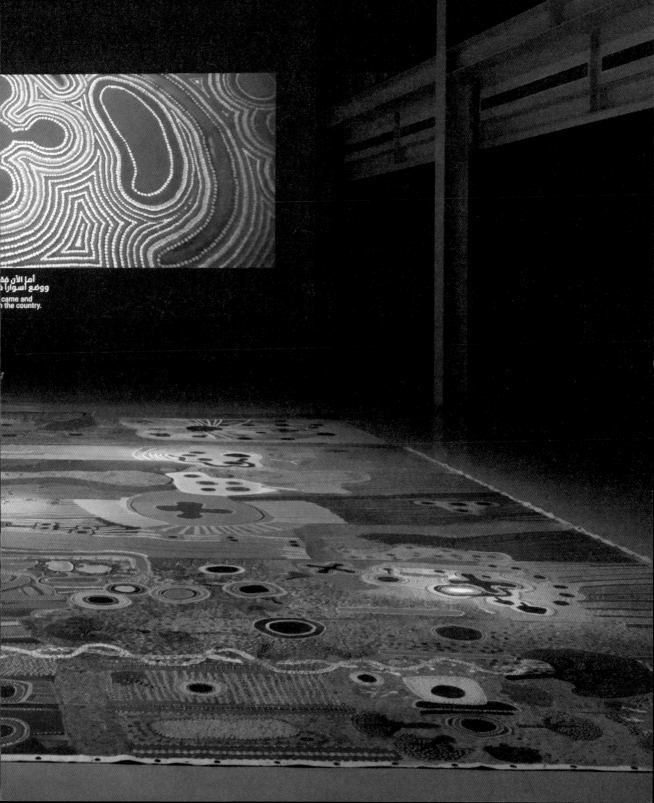

أما الآن فق
ووضع أسوار ذ
came and
n the country.

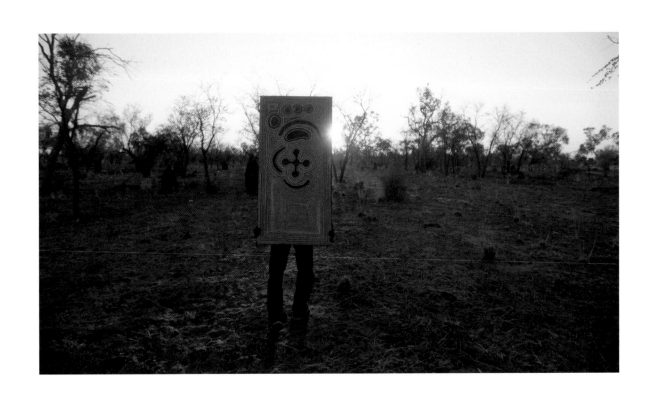

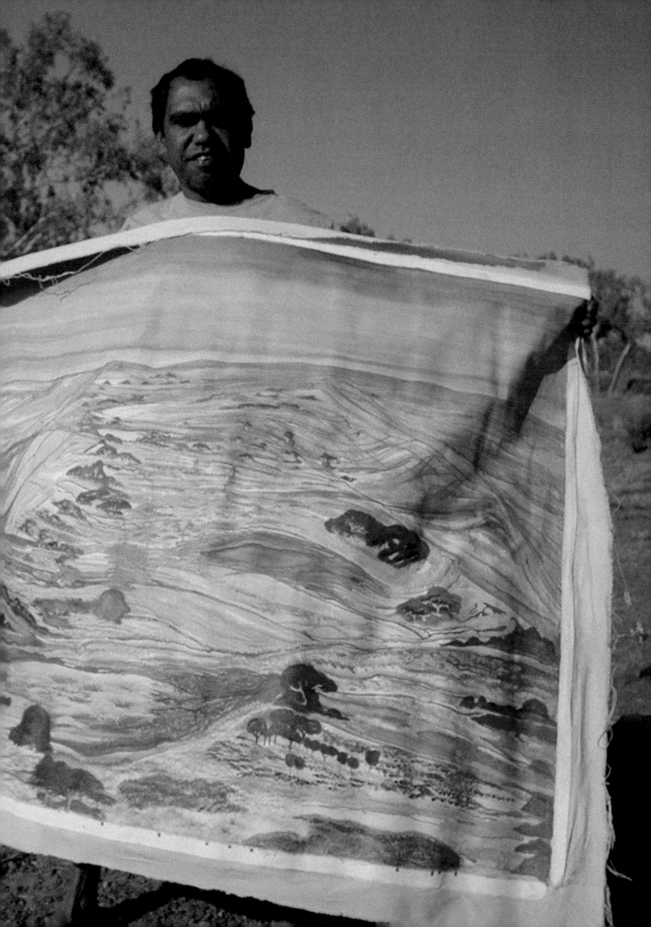

*Crimes of Solidarity |
Crimes de solidarité*,
2020

I've he
J'ai entend

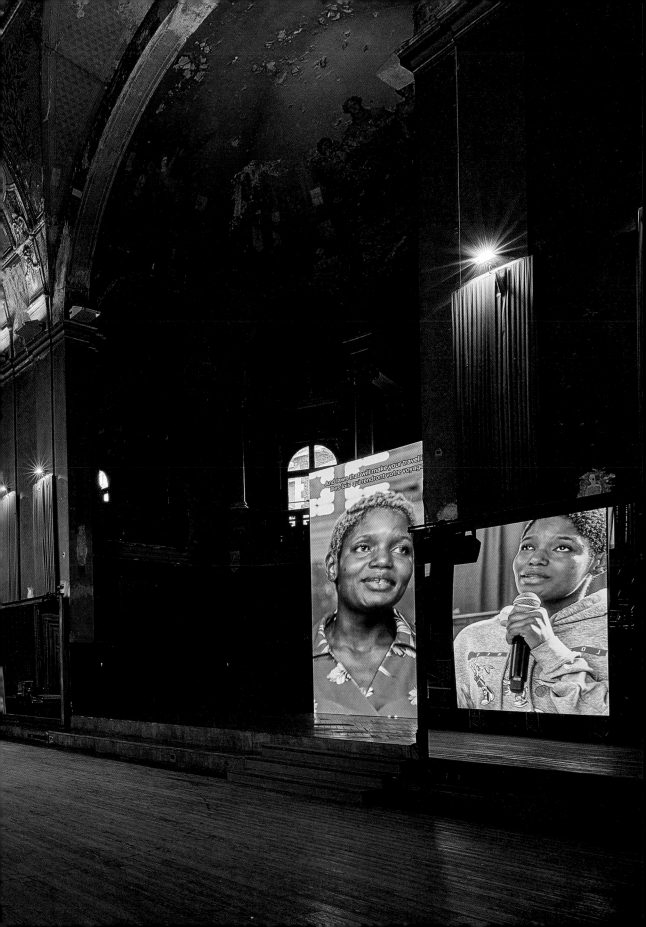

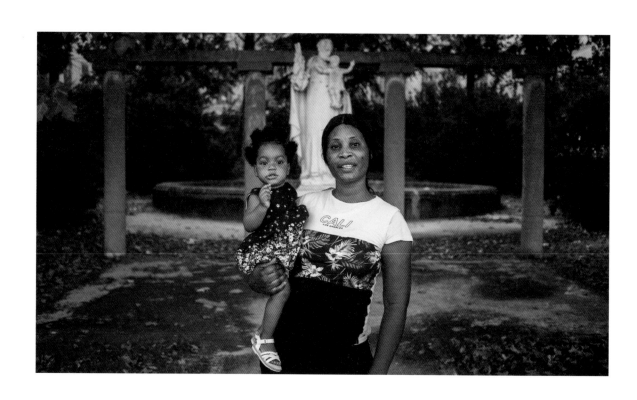

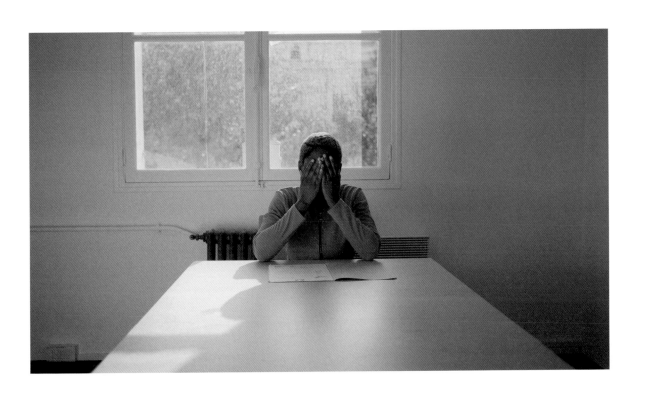

Exhibited and Related Works

The Specter of Ancestors Becoming, 2019

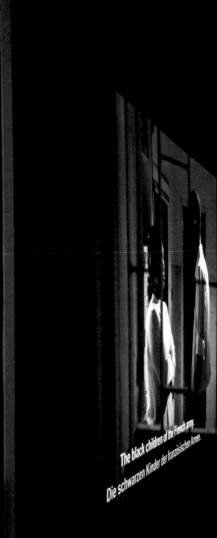

The black children of the French army.
Die schwarzen Kinder der französischen Armee.

The black c
Die schwarzen H

ch army.
schen Armee.

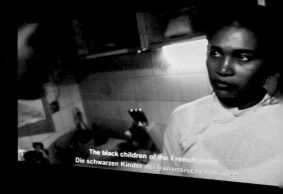

The black children of the French
Die schwarzen Kinder der französischen

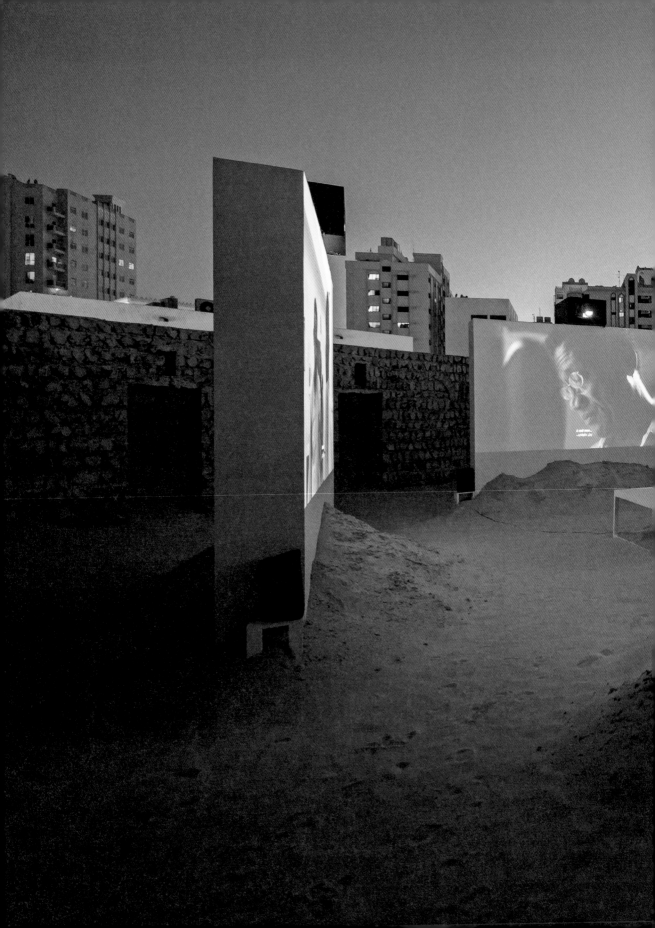

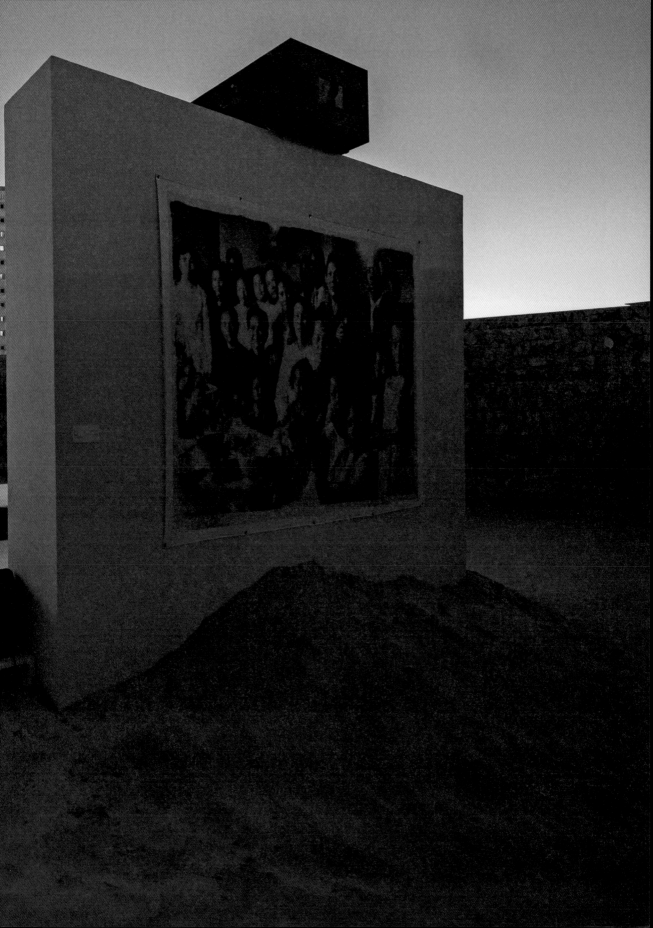

Saigon, March

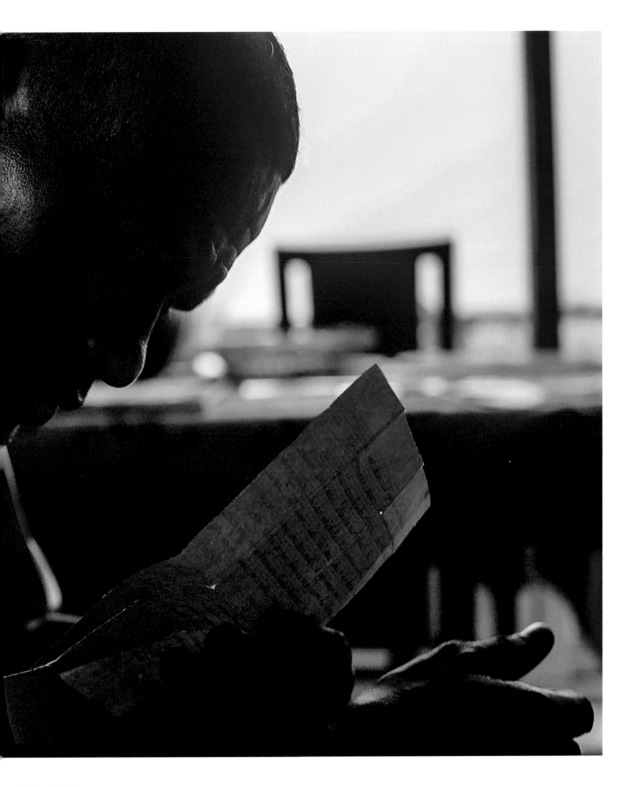

12th, 1956

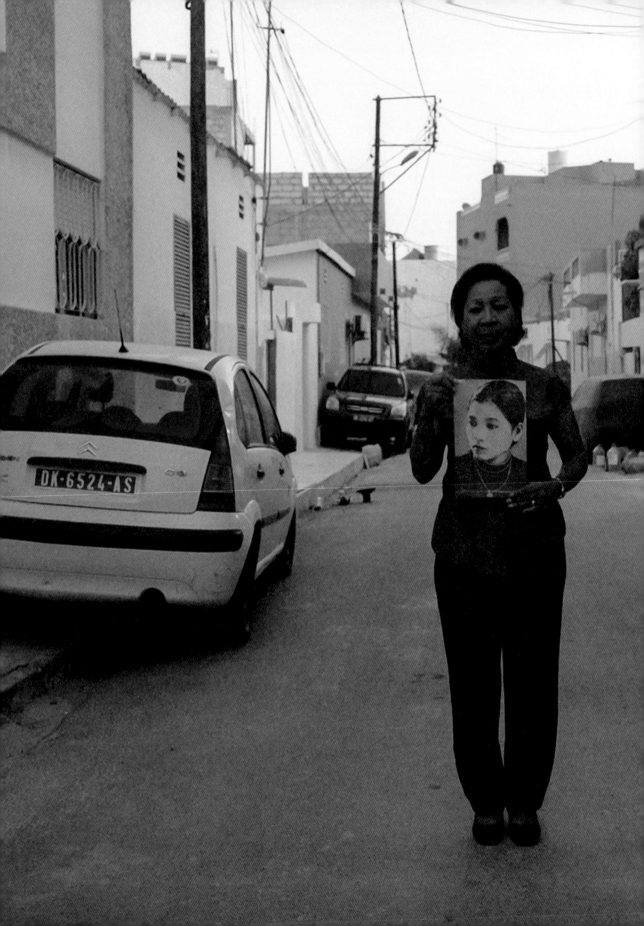

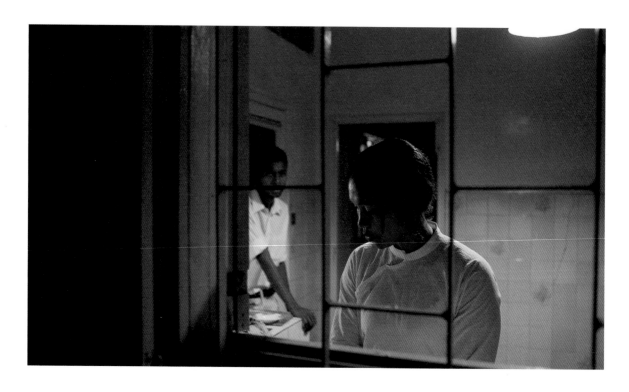

Our home is here.

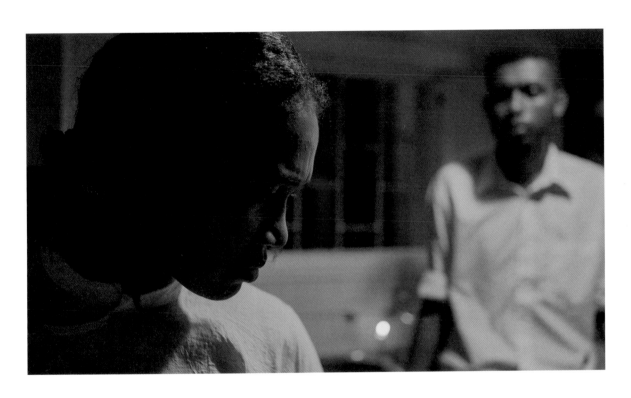

Bottom line is we're leaving with or without you.

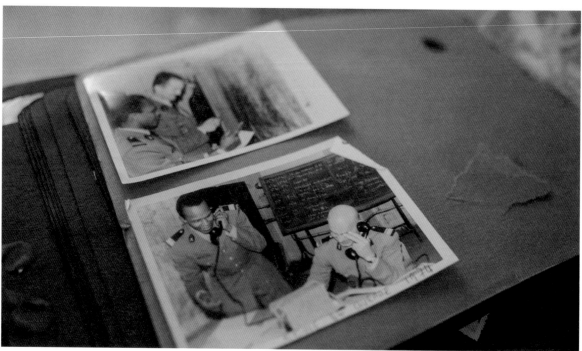

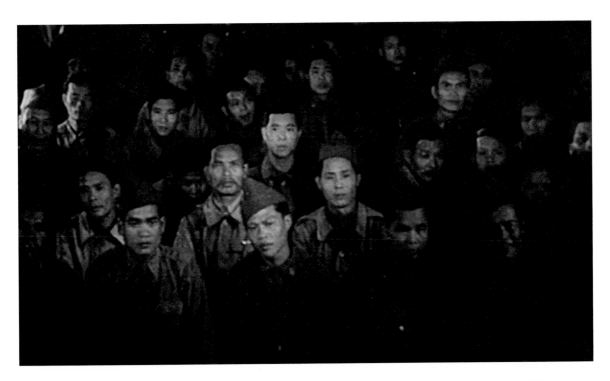

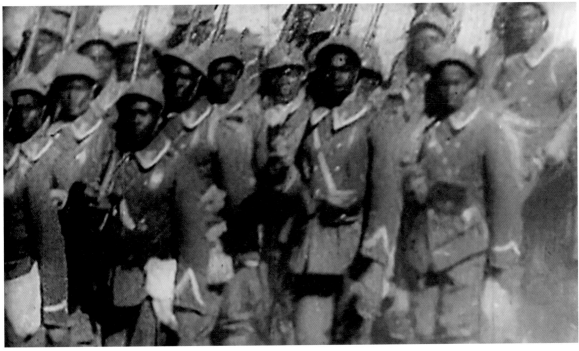

141

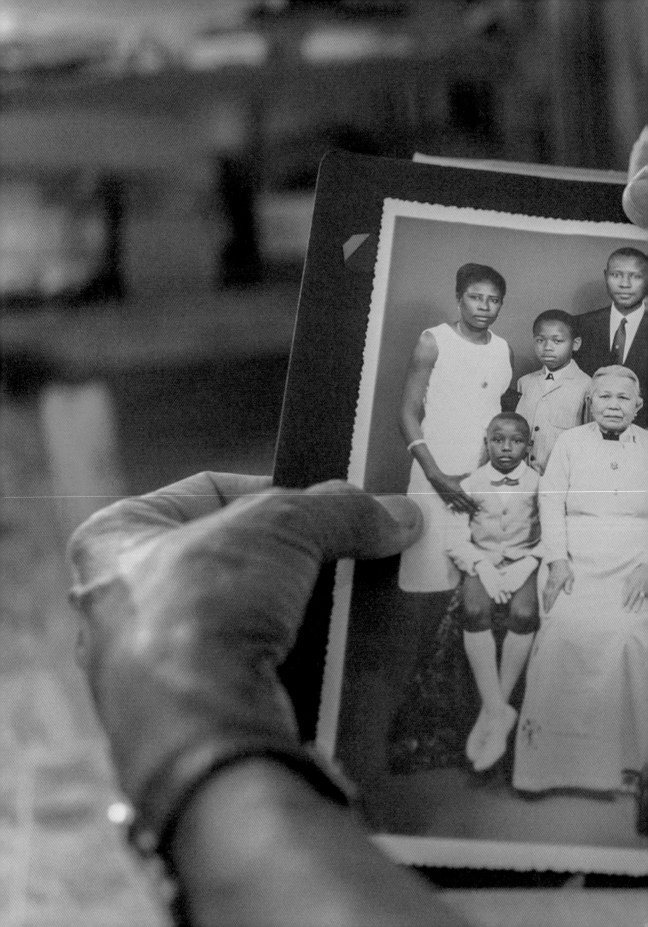

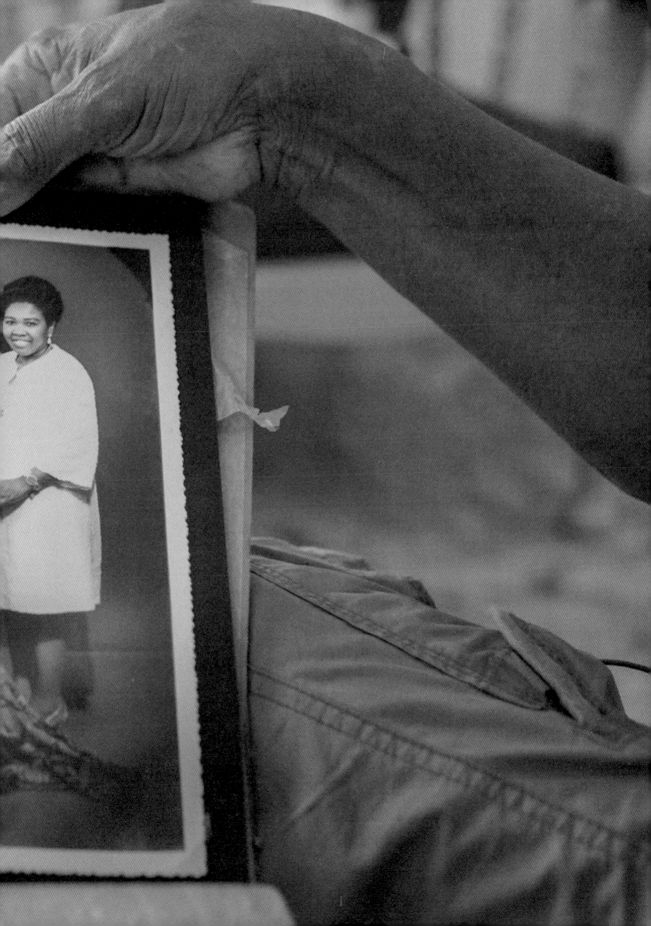

144

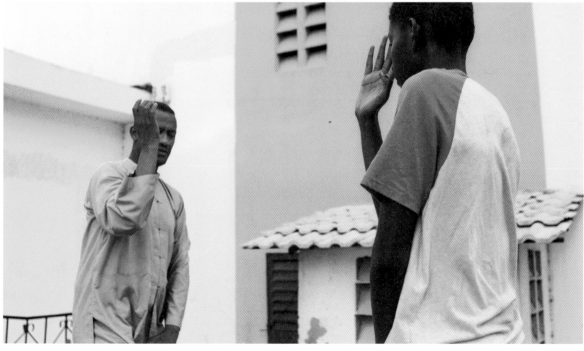

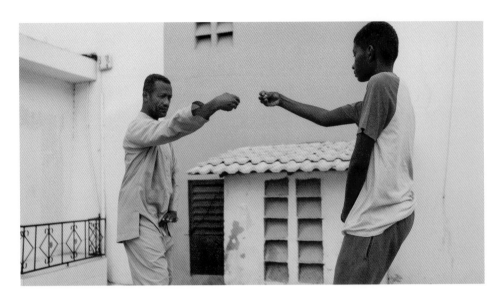

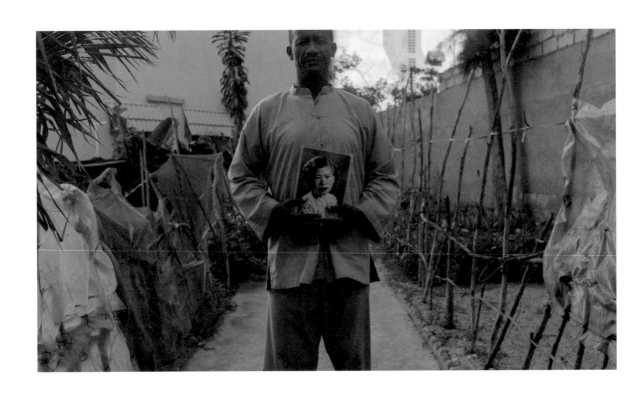

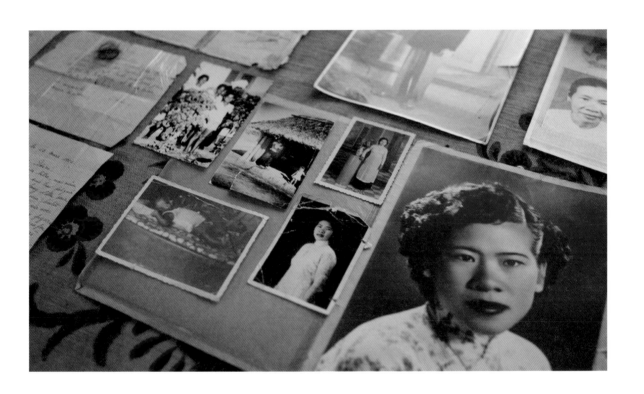

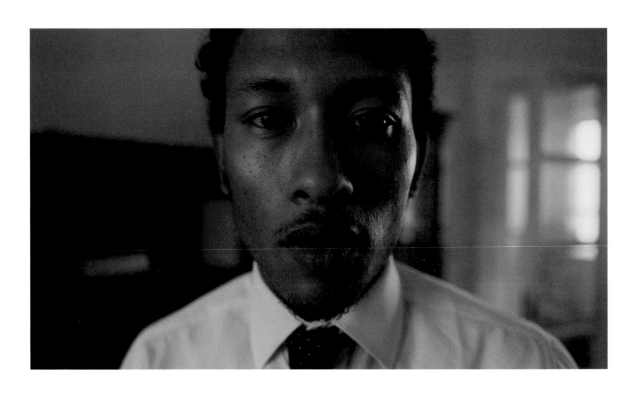

Erasing is a choice. Remembering is a choice as well.

I'm sure you felt the same love for me.

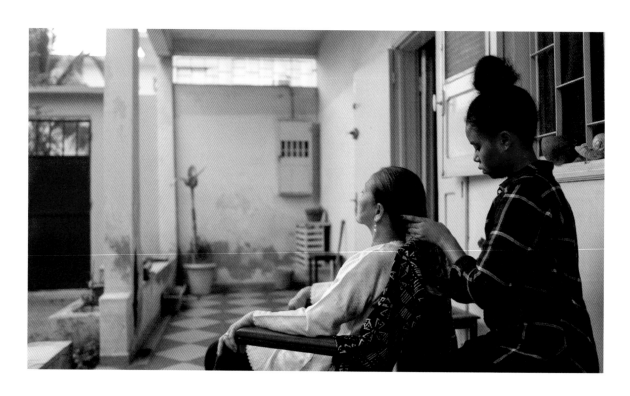

I remember you stood in front of a rifle in Indochina to save a black man.

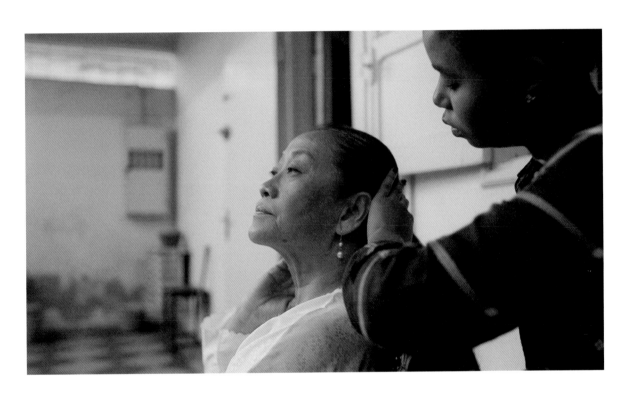

How do you remember?

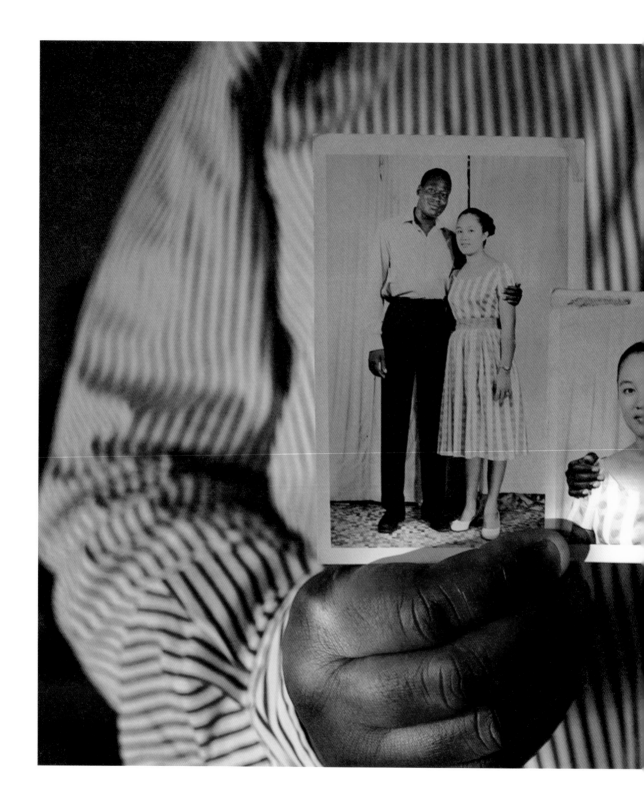

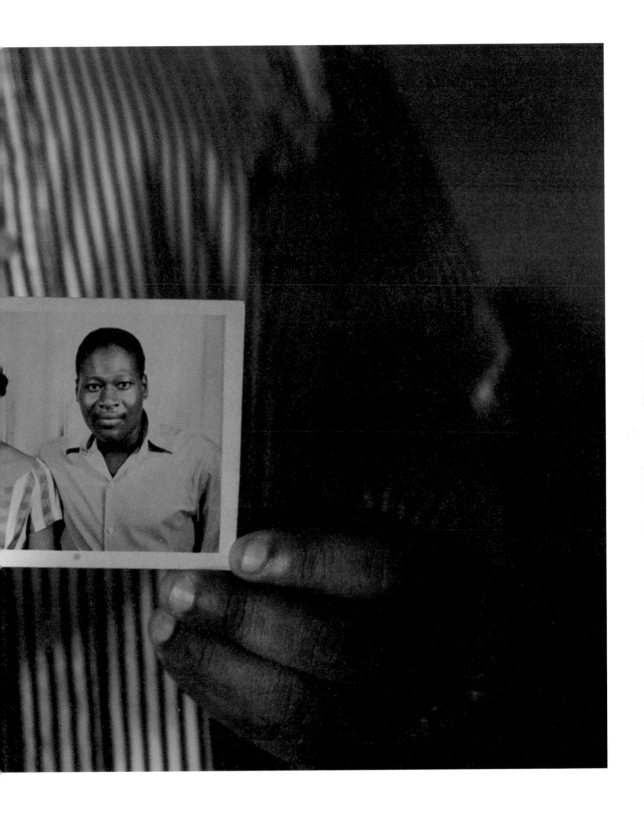

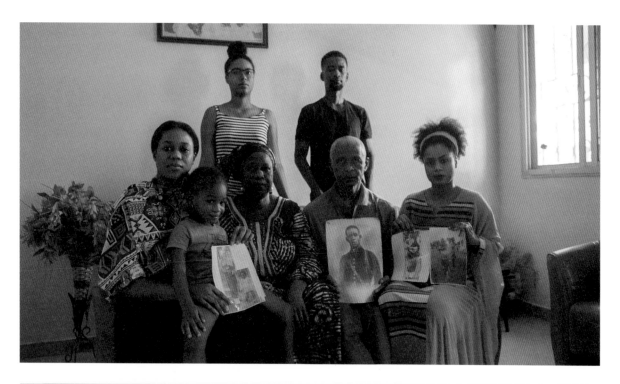

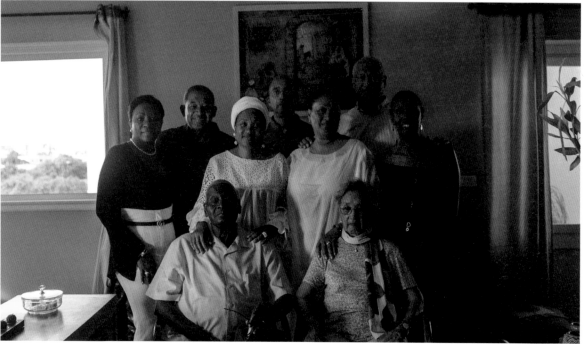

161

From the Archives
of Families in Senegal

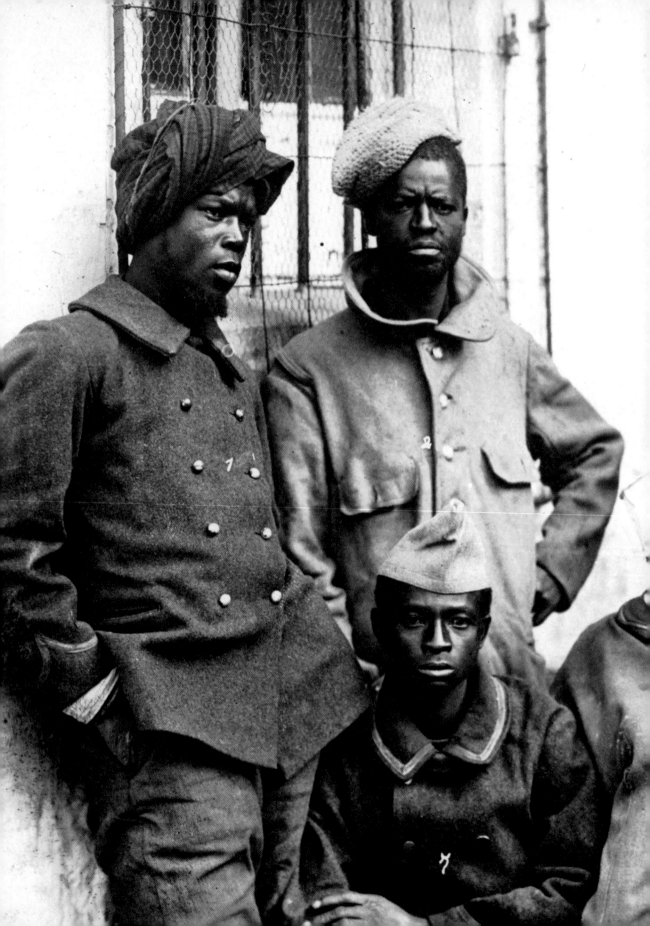

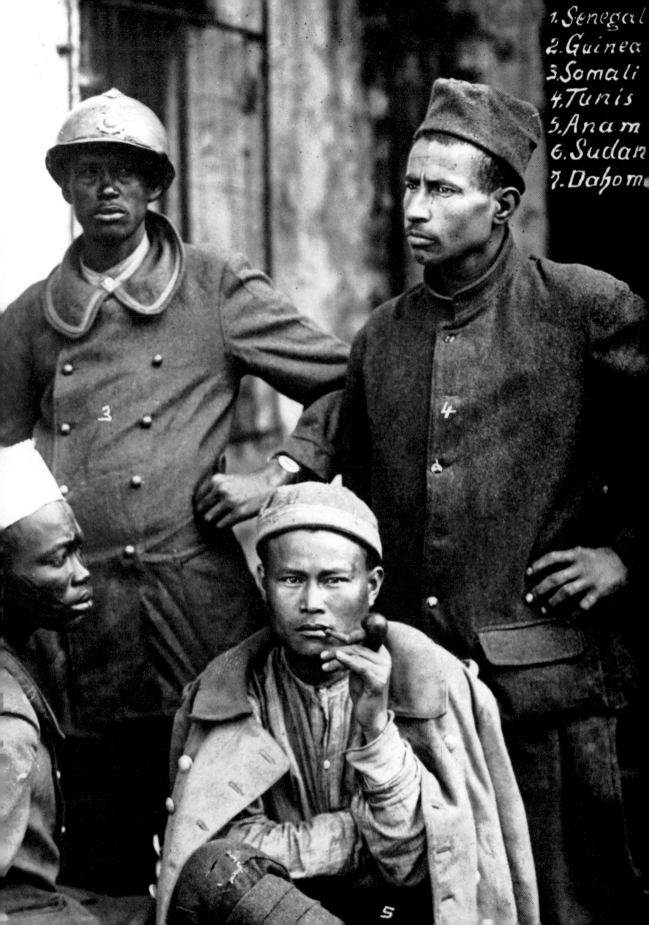

1. Senegal
2. Guinea
3. Somali
4. Tunis
5. Anam
6. Sudan
7. Dahom

Previous spread: *Tirailleurs* from French colonial African territories held as prisoners of war by the German Empire following the "Battle of the Hills" in the province of Champagne, France, during World War I, June 1917

Opposite: Family portraits on card. Mrs. Beye Nguyen Thi Nii and her husband, Mr. Madiaw Beye Ibrahima, surrounded by their children (Madiaw Beye-Marie, Awa, Massata, Assane, Ousseynou, Mame, Fatou, Lika, Khary, Mbathio, and Fama). Haïphong, Marseille, Dakar, ca. 1937–50

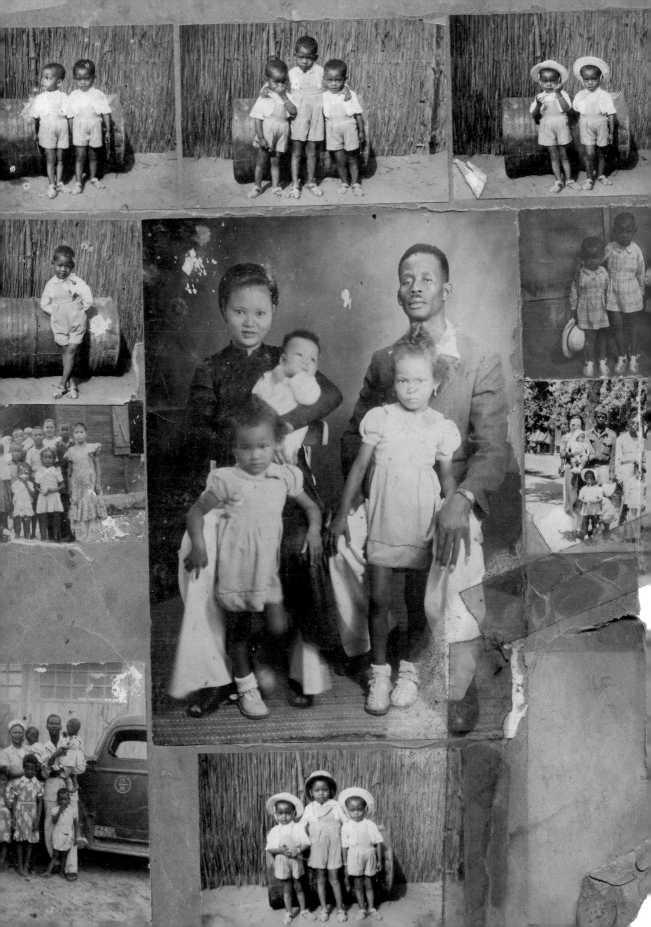

Ms. Beye Nguyen Thi Nii surrounded by her children (Madiaw Beye-Marie, Massata, Assane, Ousseynou). Dakar, n.d.

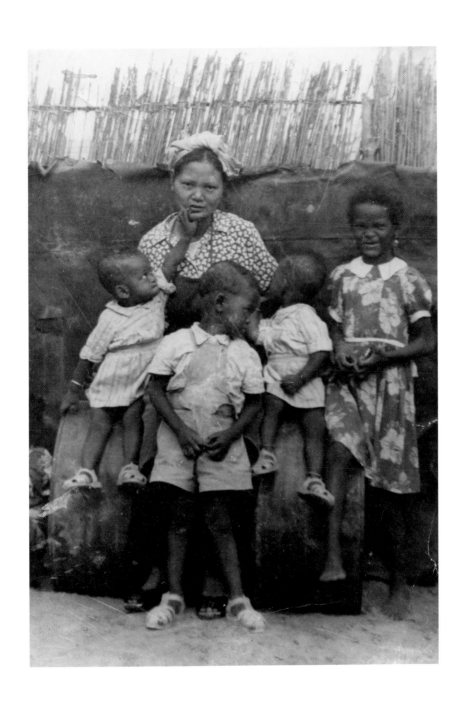

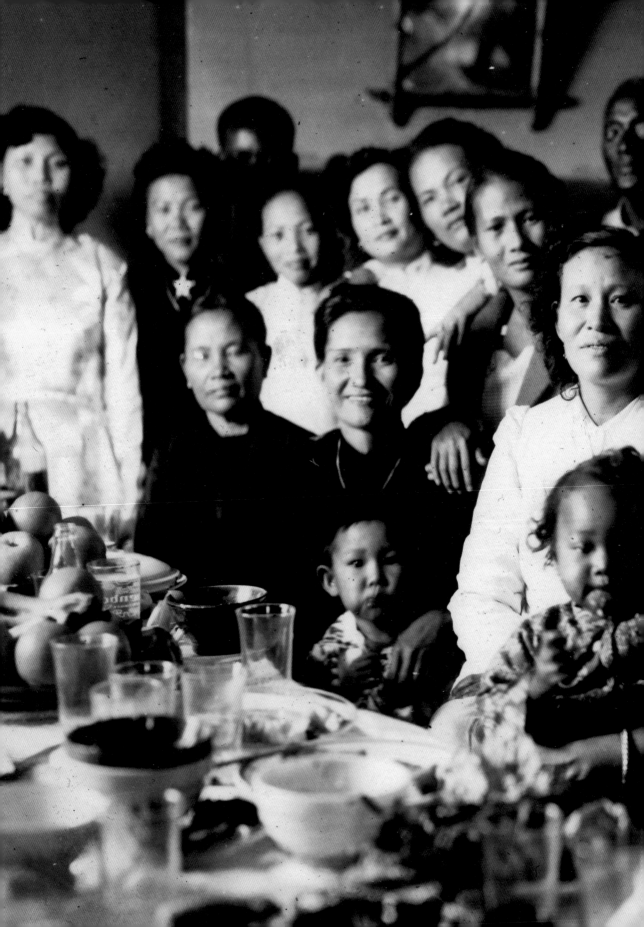

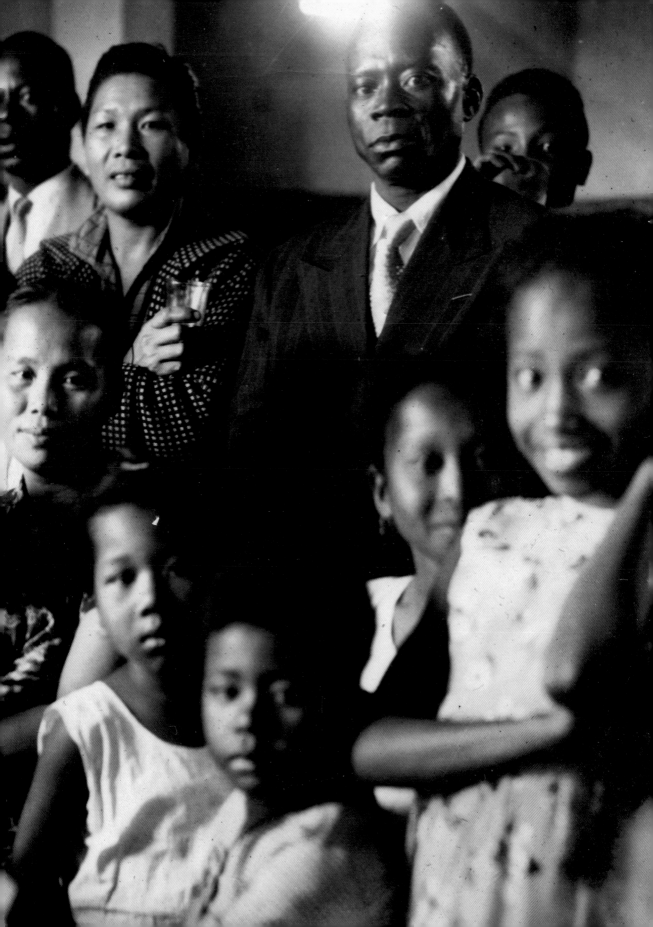

Previous spread: Tết celebration at Mr. Hoang Van Hop's Golden Dragon restaurant, rue Jules Ferry. Among the guests: Mrs. Sonko, Mrs. Thanh Keller, Mrs. Dabo, Mrs. Ndoye, Mrs. Faye Ngo Thi Con, Mr. Faye, Mr. Fara Gomis, Mr. Dô Van Kim, Mr. Ndoye. Those seated are Mrs. Hô Thi Chau, known as Mrs. Jacky, and her son Jean Claude Dô Van; Mrs. Gomis Kim Hoan Doan; Mrs. Diallo and her daughter, Suzanne Diallo (Fann Hock); Claire Gomis; and Monique Gomis. Dakar, 1958

Opposite: Studio photograph. From left to right: Fatou Faye, Jeanne Faye, Ousmane Faye, Badiène Astou Faye, Assane Faye, Badara Faye, Omar Faye, and Mme. Faye Ngo Thi Con. Dakar, ca. 1956

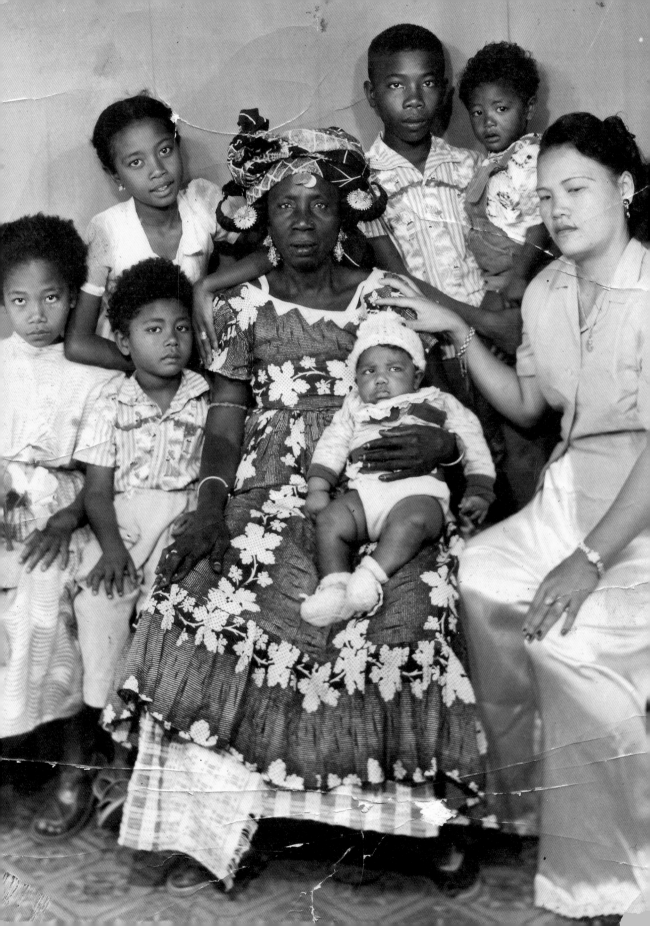

Two soldiers at prayer time. Press Information Service - Cinema-Photo Section.
Hanoi, n.d.

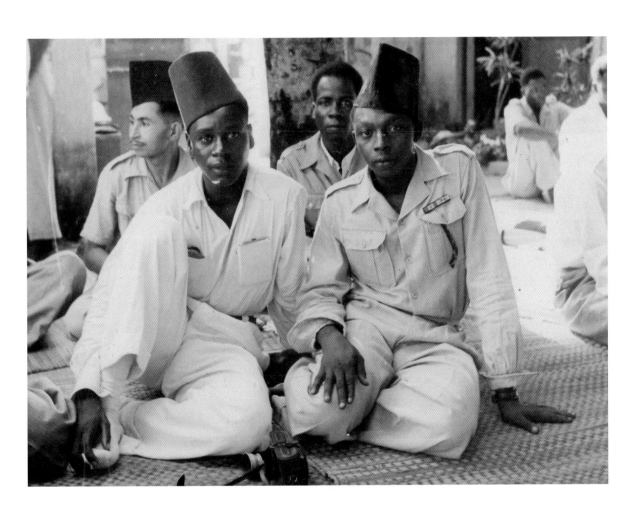

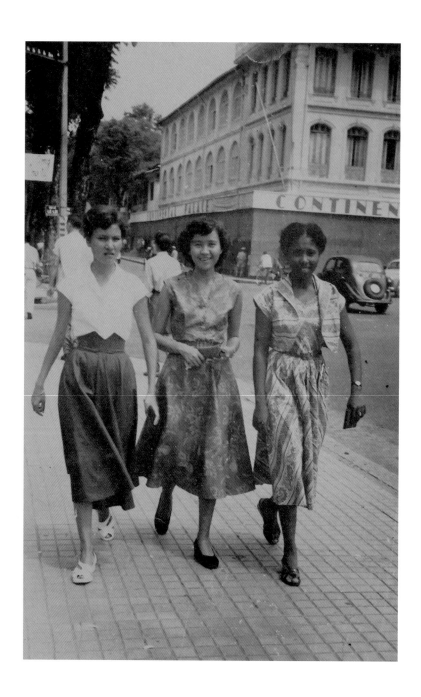

A walk through the streets of Saigon. Ms. Seck Jeanne Michèle Fontan (right)
and friends, ca. 1944

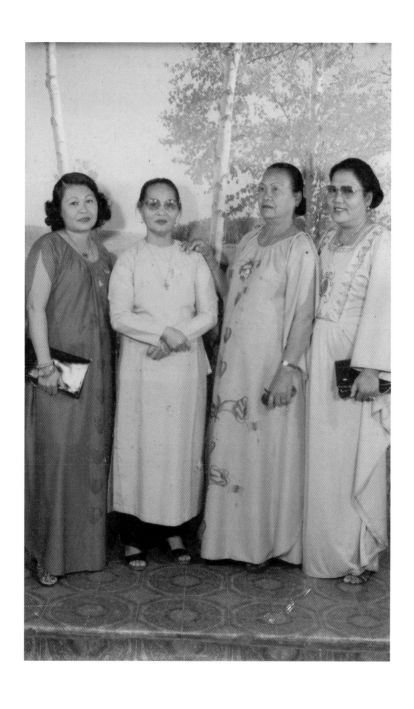

From left to right: Ms. Diallo, Ms. Diouf Nguyen Thi Thanh,
Ms. Faye Ngo Thi Con, Ms. Gueye Alioune. Dakar, n.d.

Above: Portrait of Mrs. Barry Soeum Prean and her husband, Mr. Aly Barry.
Dakar, n.d.

Opposite (top): A family meal. Ms. Hô Thi Chau, known as Ms. Jacky, surrounded
by two friends, Ms. Ndiaye Deo Nang Phong and Ms. Ndiaye Bà Cu, and her
grandchildren. Dakar, ca. 1985

Opposite (bottom): A reunion with friends. Among the guests: Mrs. Dabo,
Mrs. Moc, Mrs. Ndiaye Bà Cu, Mrs. Ndiaye Deo Nang Phong, Mrs. Seck Han
Thi Lan, and Mrs. Diouf Nguyen Thi Thanh, n.d.

The Sounds of Cannons Familiar Like Sad Refrains / Đại Bác Nghe Quen Như Câu Dạo Buồn, 2021

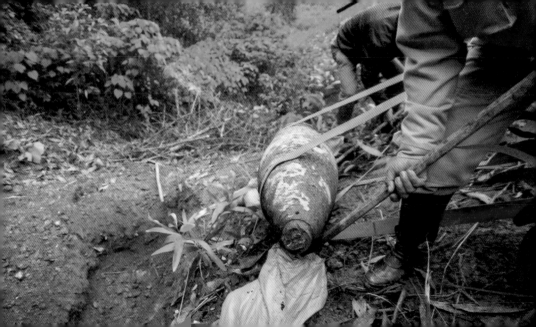

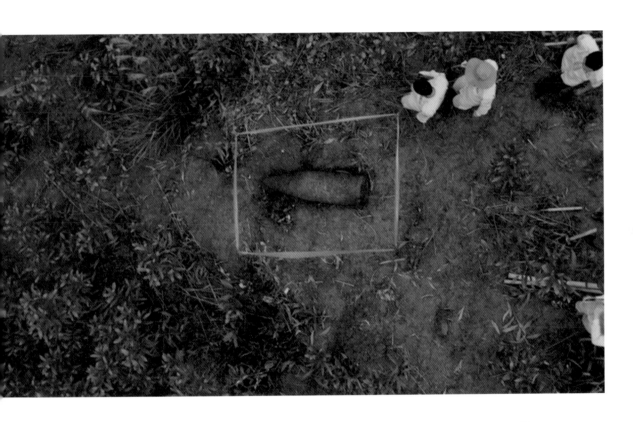

USS Bainbridge, là tàu khu trục chỉ huy, và là tàu khu trục lớn nhất...

What's the karma for bombs and bullets?

Nghiệp chướng cưa bom đạn sẽ là gì?

A Vietnamese house burns red at the end of the hamlet

Cửa nhà Việt Nam cháy đỏ cuối thôn

The Unburied Sounds of a Troubled Horizon, 2022

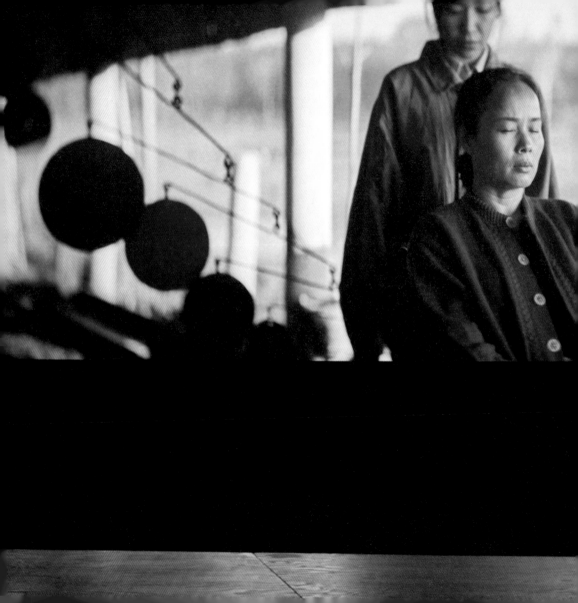

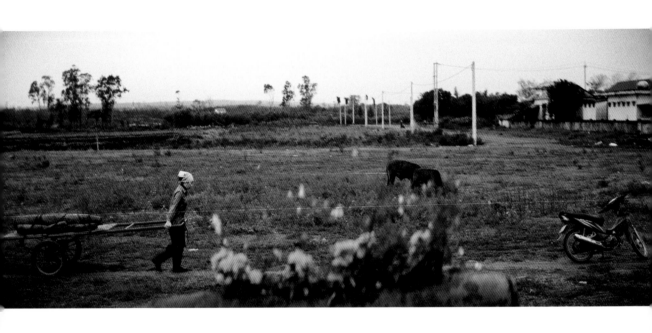

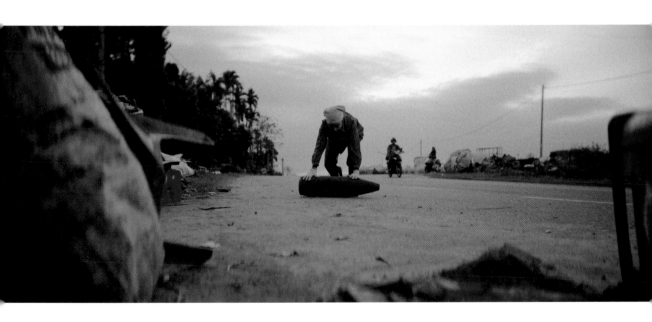

197

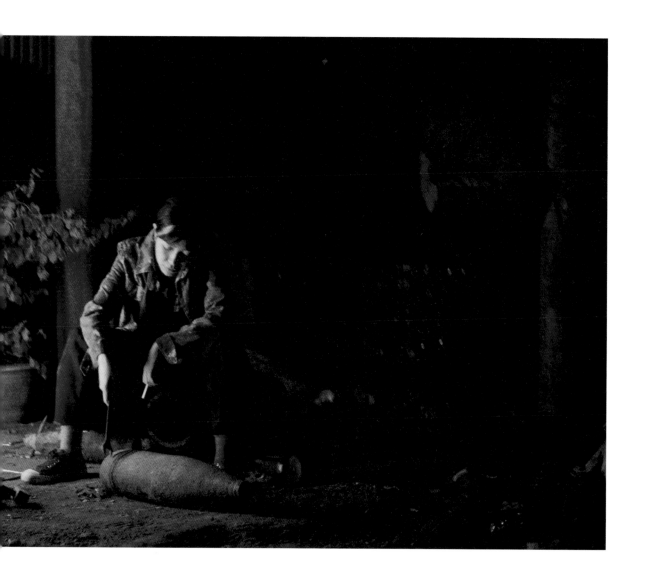

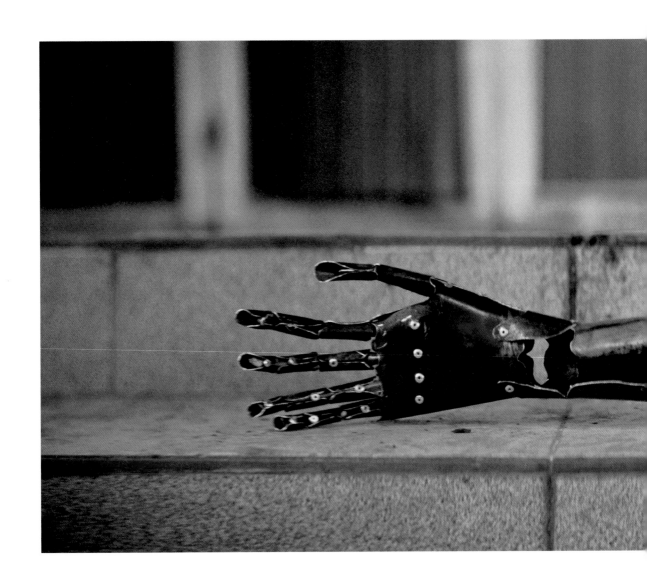

211

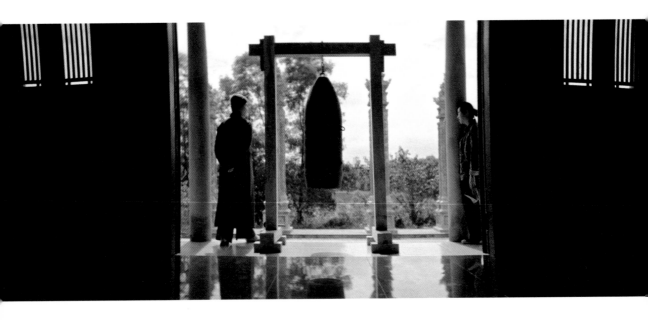

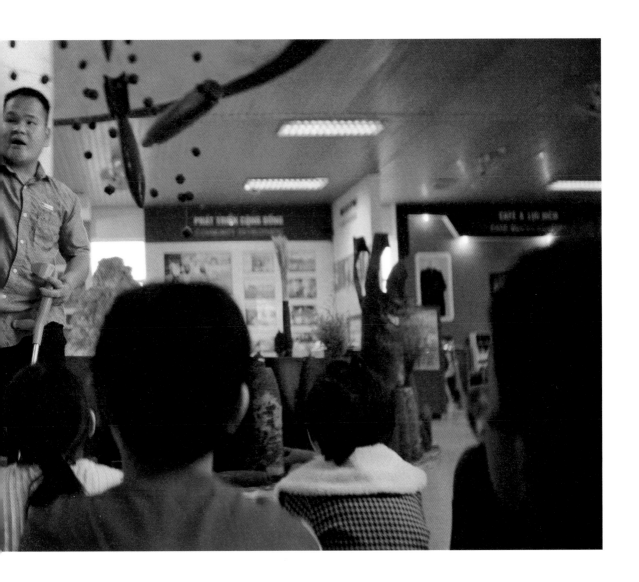

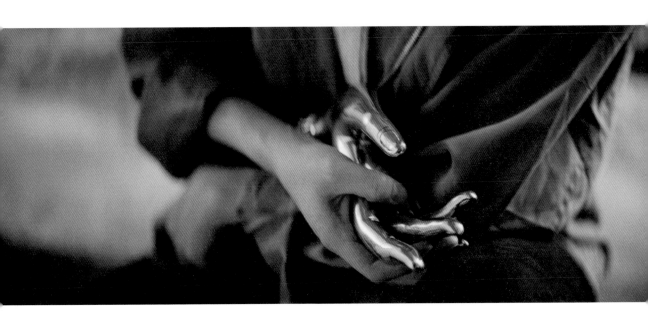

219

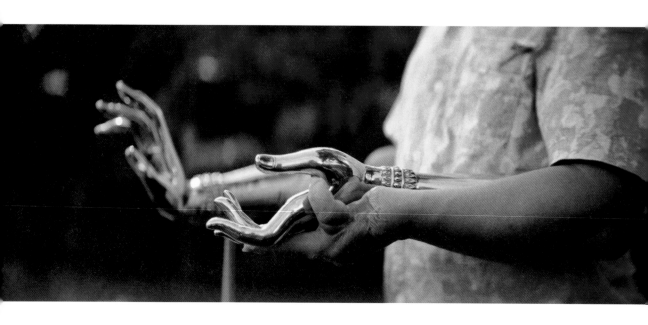

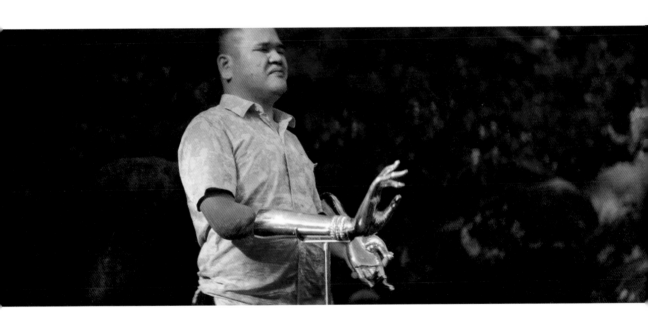

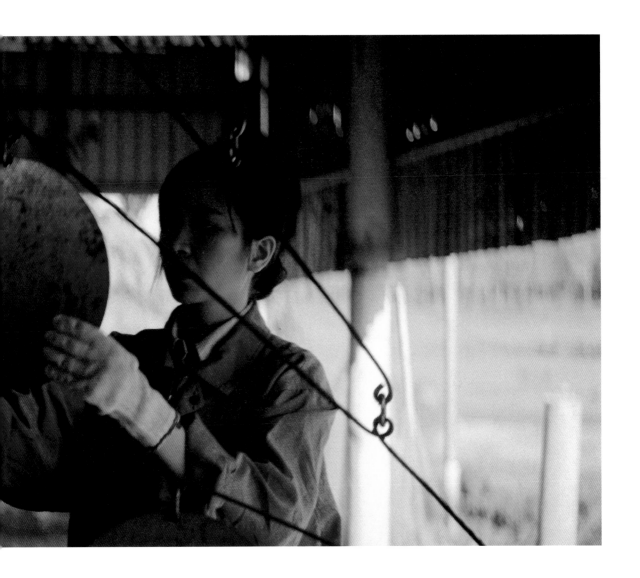

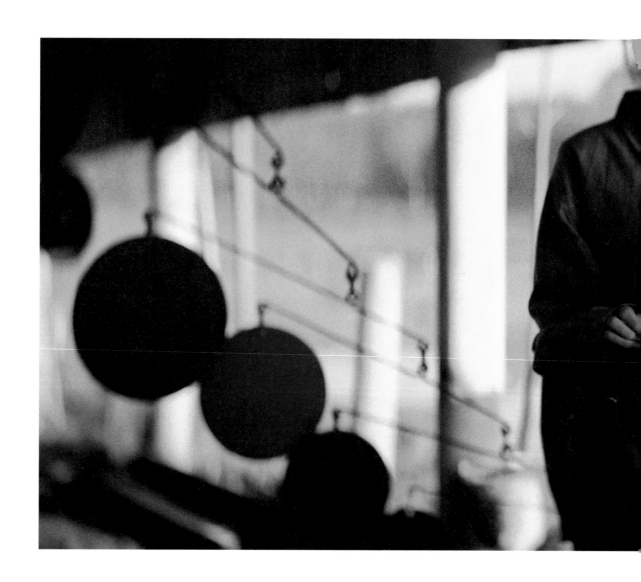

Display of prosthetic arms and legs at the Mine Action Visitor Center ran by
Project RENEW in Quảng Trị, Vietnam. Production stills from *The Unburied Sounds
of a Troubled Horizon*, 2022

227

Unexploded ordnance, 16 in, 50-caliber, Sông Ngân hamlet, Linh Thượng Village,
Gio Linh district, Quảng Trị, January 14, 2021

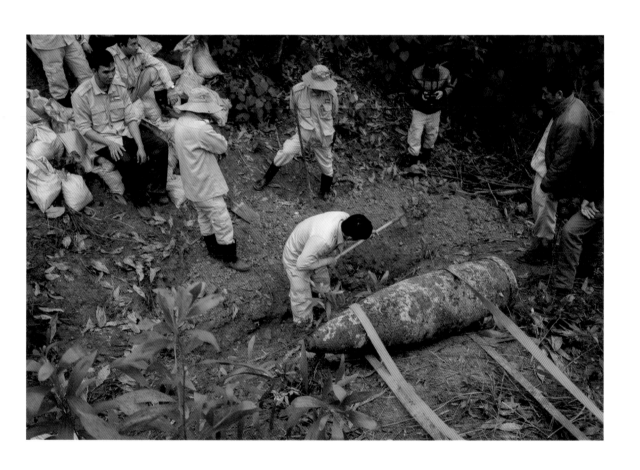

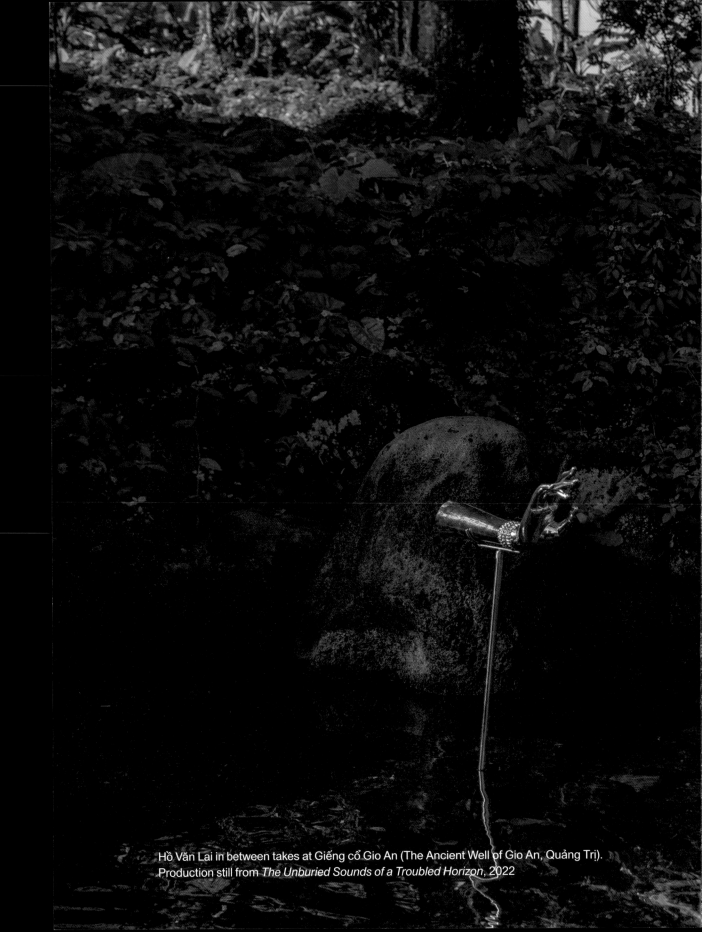

Hồ Văn Lai in between takes at Giếng cổ Gio An (The Ancient Well of Gio An, Quảng Trị).
Production still from *The Unburied Sounds of a Troubled Horizon*, 2022

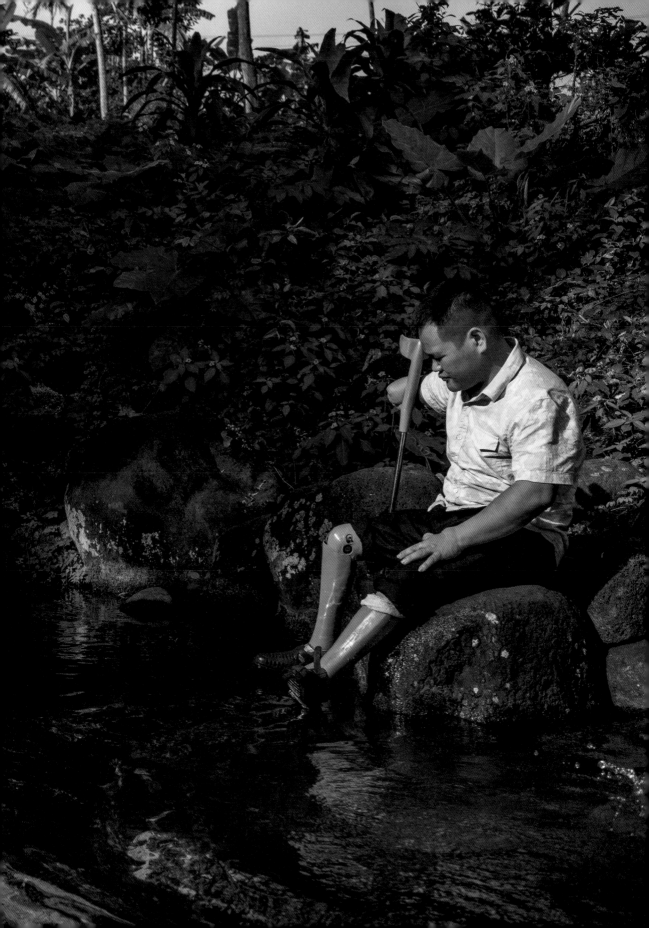

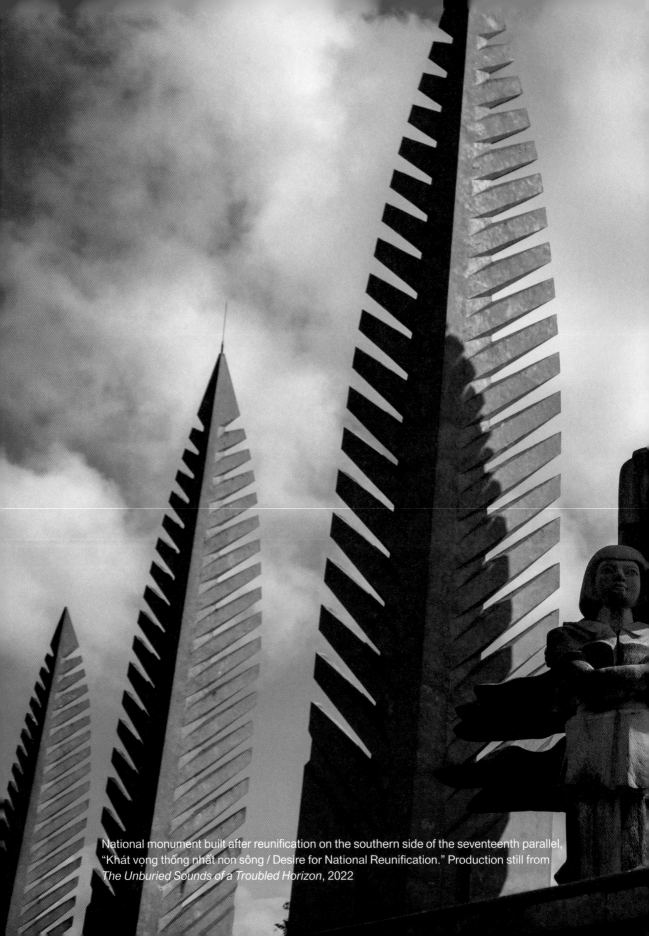

National monument built after reunification on the southern side of the seventeenth parallel, "Khát vọng thống nhất non sông / Desire for National Reunification." Production still from *The Unburied Sounds of a Troubled Horizon*, 2022

*Objects from
Ordnance, 2022–23*

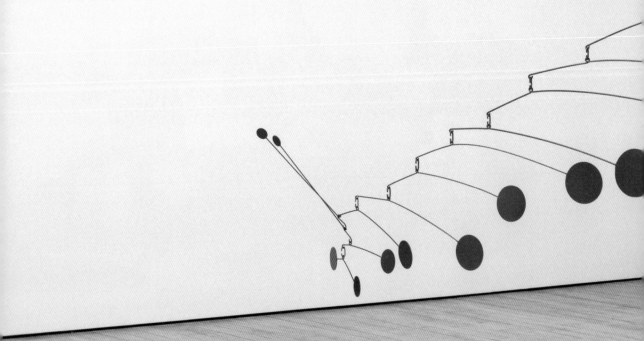

Red Fiery, 2022

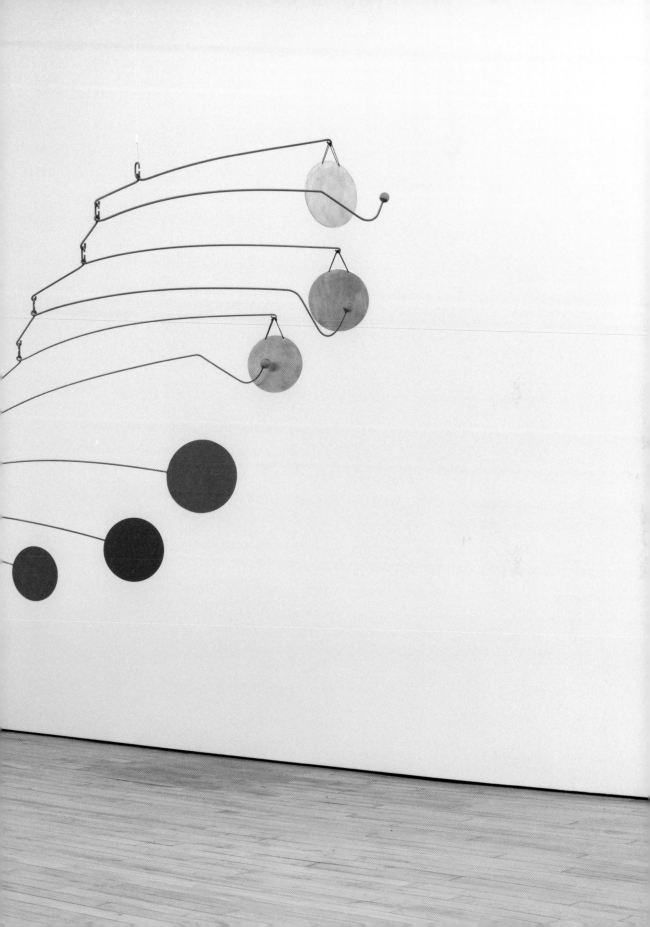

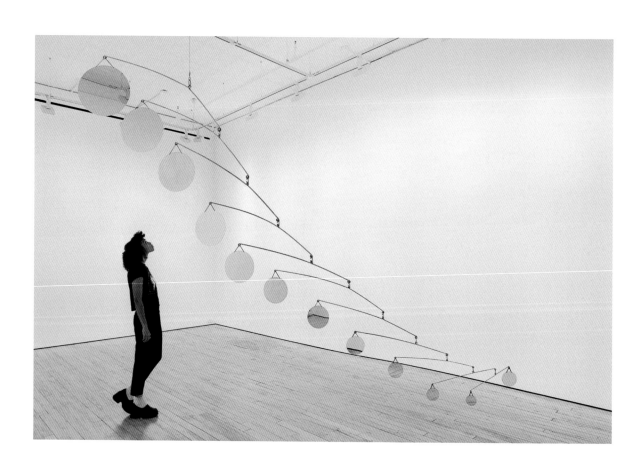

A Rising Moon Through The Smoke, 2022

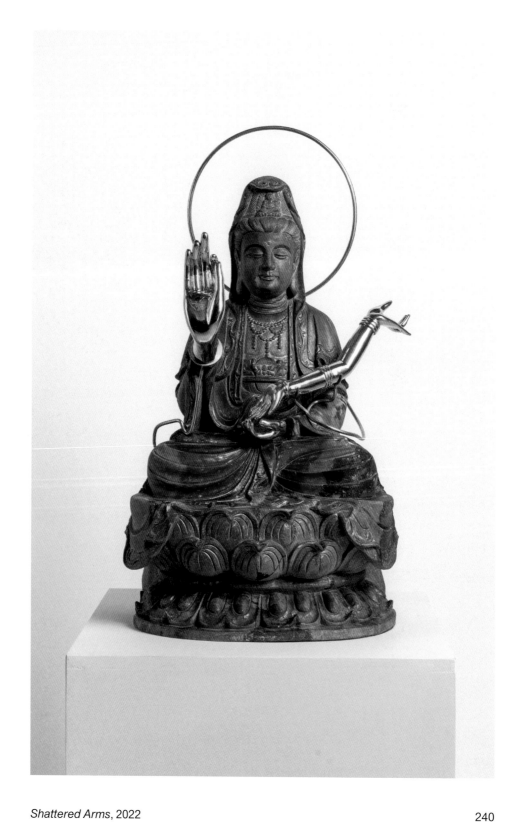

Shattered Arms, 2022

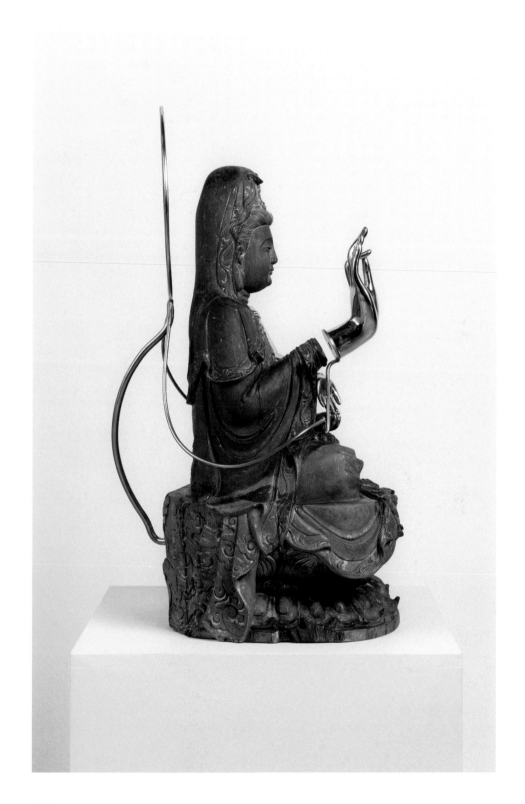

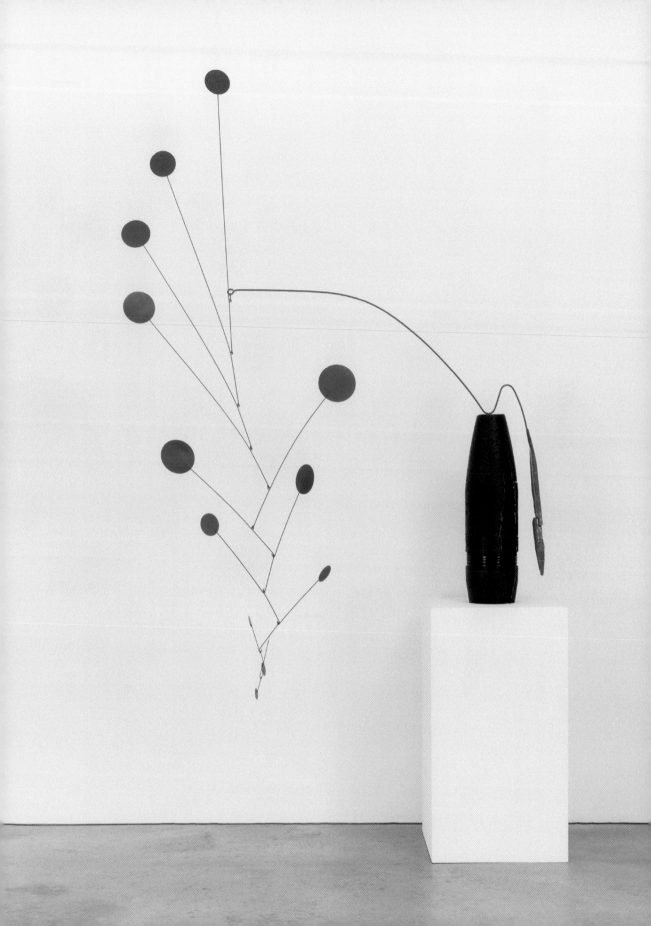

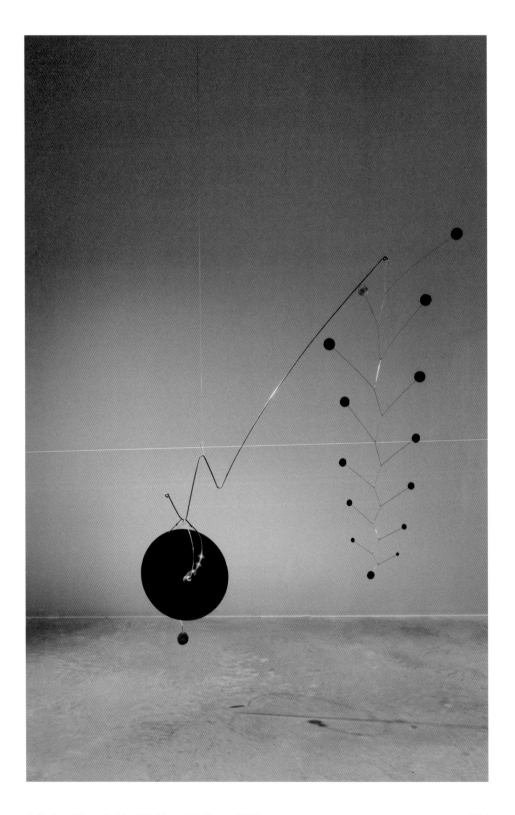

A Sullen Moon Behind Lit Mountain Tops, 2023

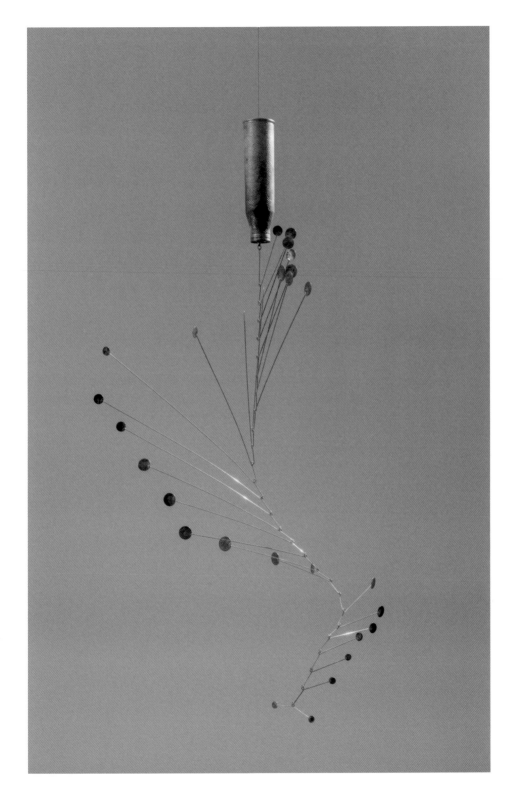

245

Fallen Fallacy, 2023

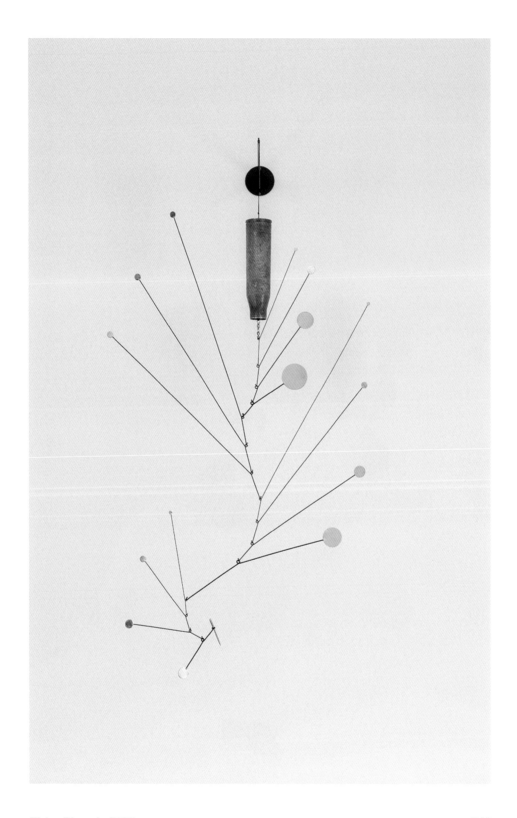

Flying Phoenix, 2022

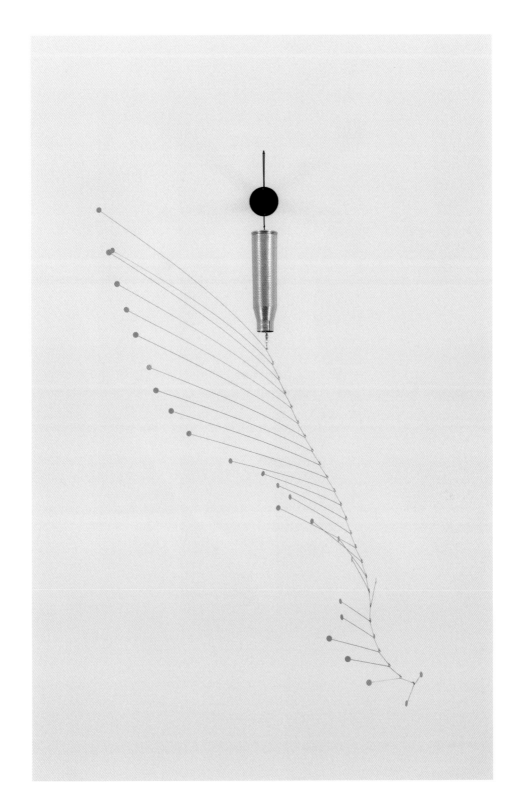

Spiral Explosion, 2022

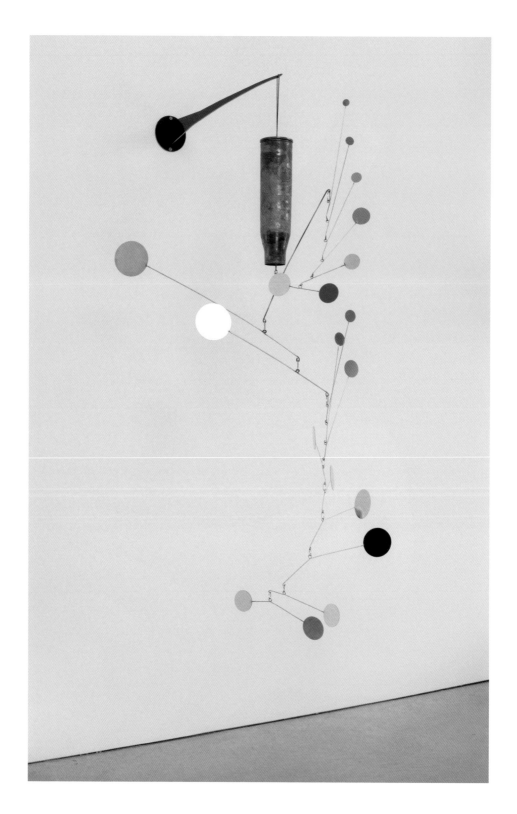

A Dragon Through Clouds, 2022

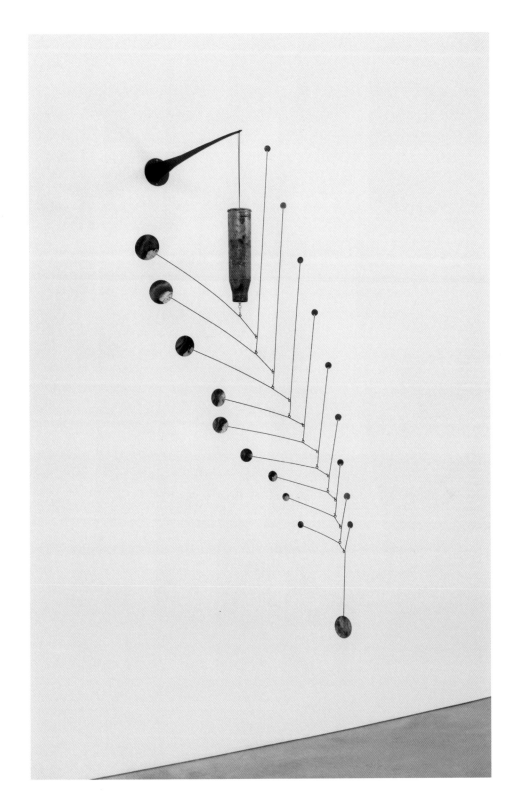

Descendant, 2022

Inside a Sound a Million Trembling Lives, 2022

Nothing is Ever Lost, Nothing Ever Gained, 2022

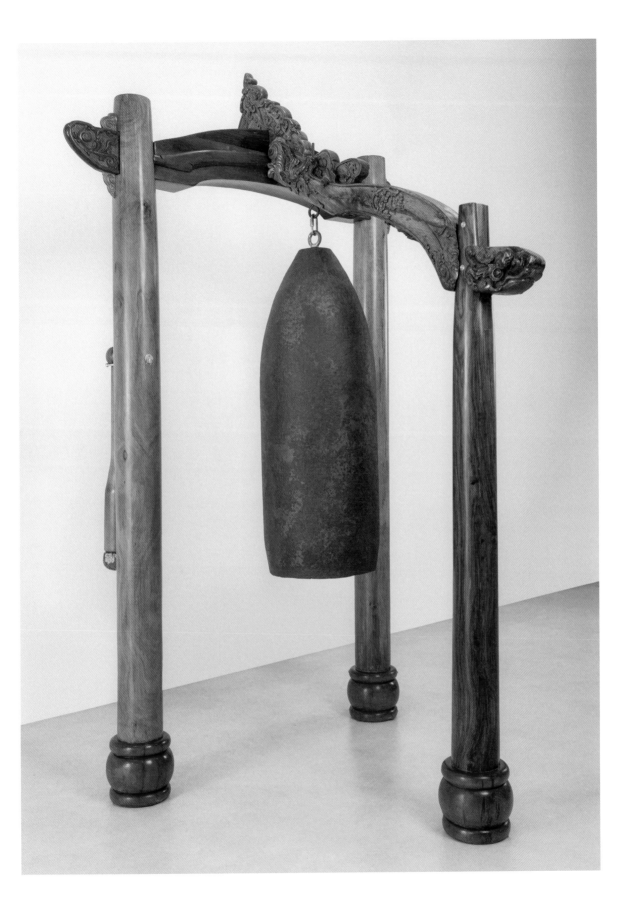

*Because No One
Living Will Listen /
Người Sống Chẳng Ai
Nghe*, 2023

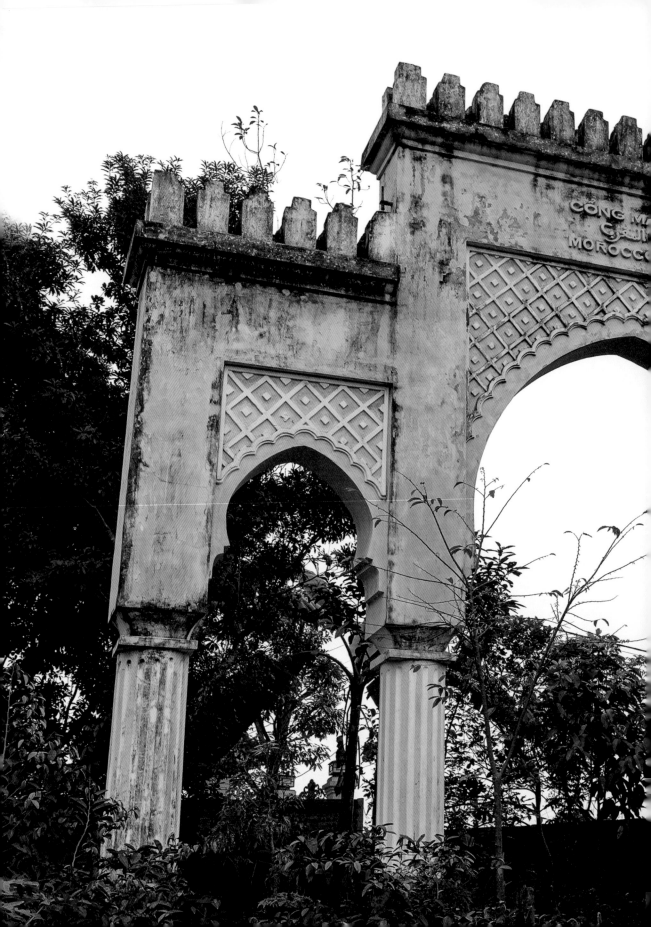

Habiba (Nguyễn Thị Xuân; third from left) and other Moroccan-Vietnamese
descendants with Mariem (Trần Thị Hồng Mây; center), who was leading
the search to find remaining descendants of Moroccan soldiers. Hanoi, 2005

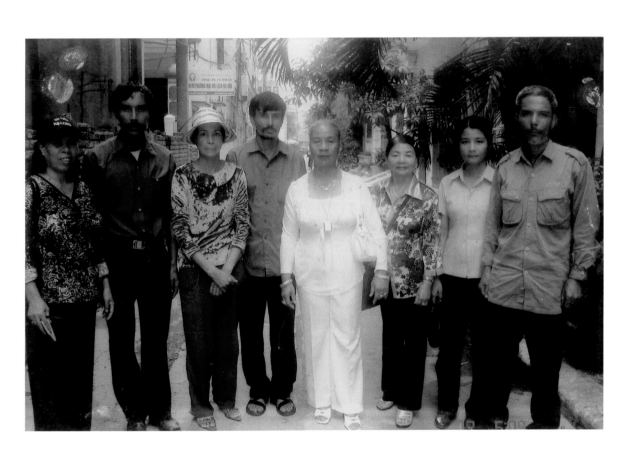

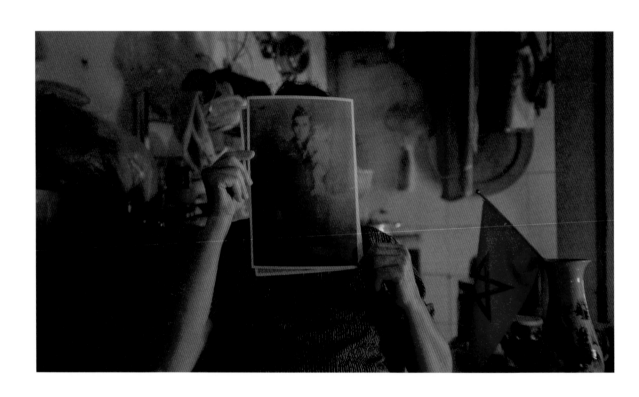

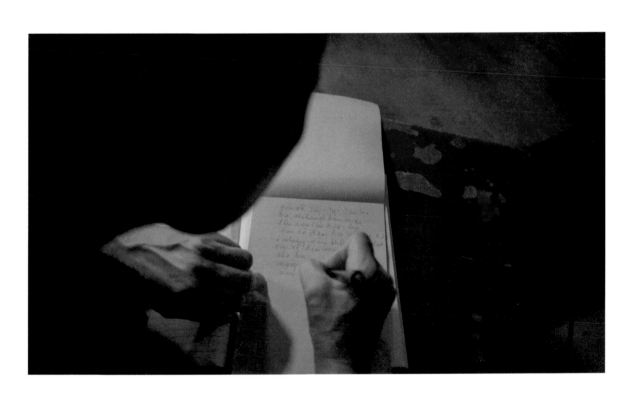

261

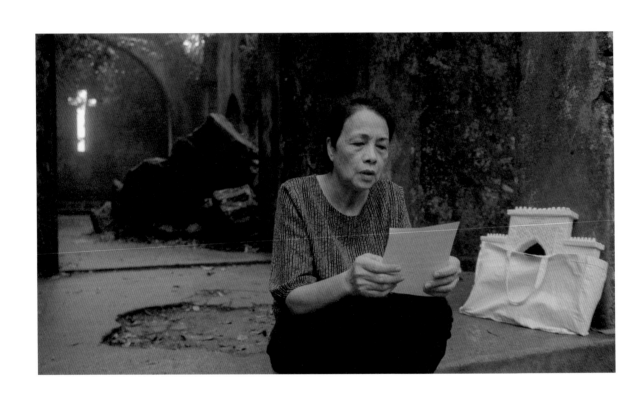

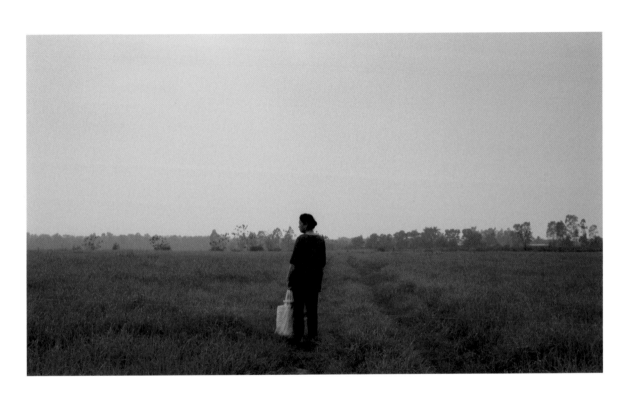

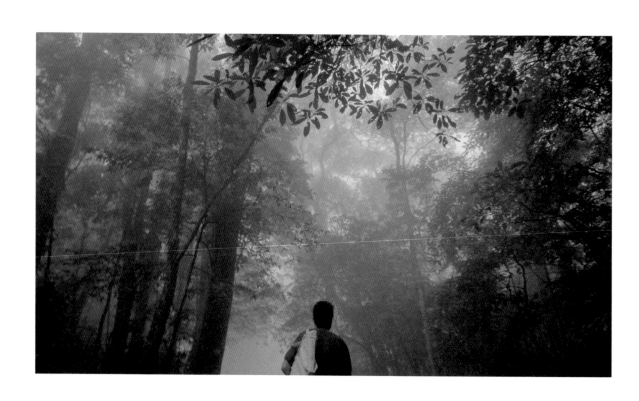

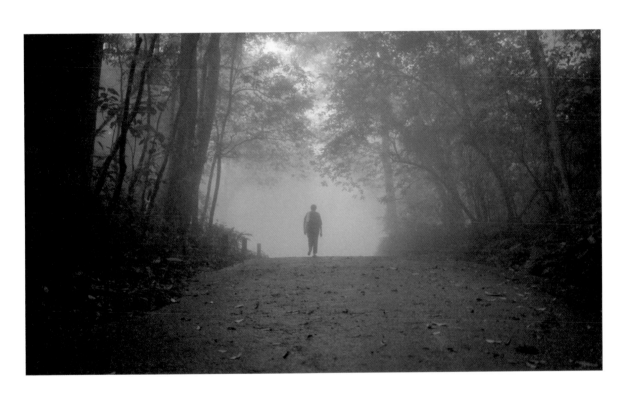

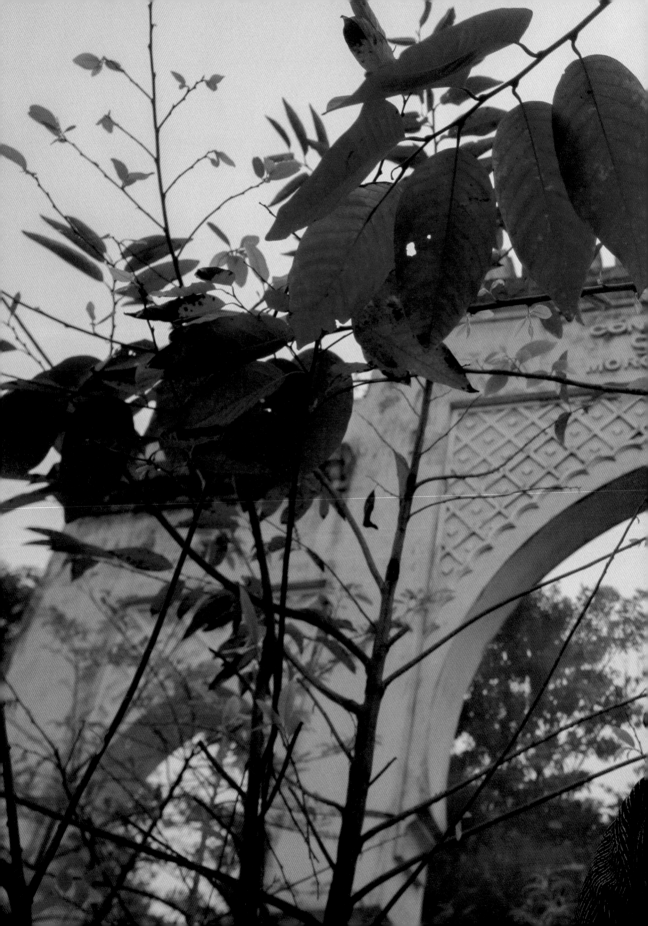

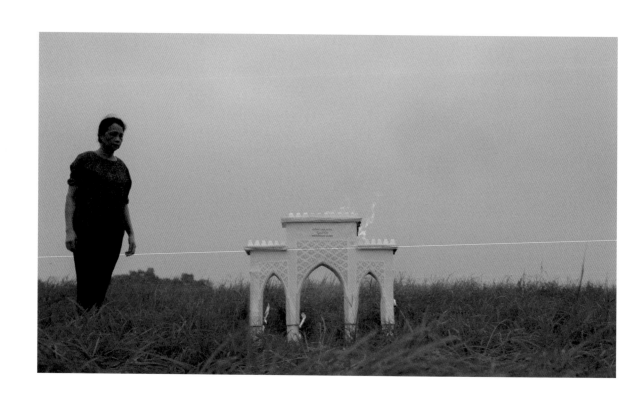

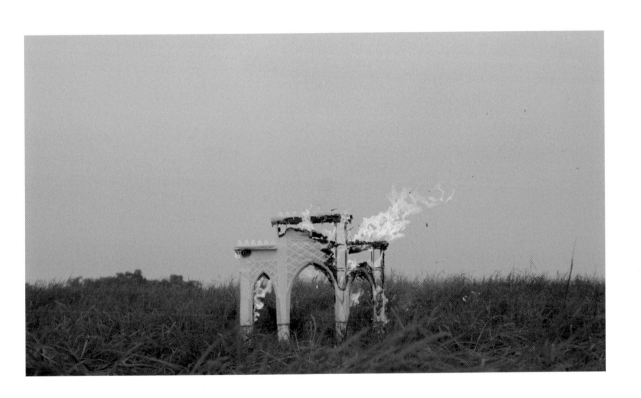

List of Illustrated Works

Unless otherwise indicated, all works
are courtesy the artist and James Cohan,
New York.

pp. 163-79
Photographs from the family archives of
Jean Claude Dô Van, Célina Falla Diouf,
Merry Beye Diouf, Ousseynou Faye,
Sophie Diagne, Marie Nguyen Thiva Tran,
and Carmen Leissa Barry. Courtesy RAW
Material Company. © Jean Claude Dô
Van, Célina Falla Diouf, Merry Beye Diouf,
Ousseynou Faye, Sophie Diagne,
Marie Nguyen Thiva Tran, and Carmen
Leissa Barry

pp. 81–91
*My Ailing Beliefs Can Cure Your
Wretched Desires*, 2017
Two-channel video installation, 1080p
each channel, color, 5.1 surround sound
18:51 min

pp. 93–99
The Island, 2017
Single-channel video, 2048 × 1080p,
color, 5.1 surround sound
42:00 min

pp. 129–61
*The Specter of Ancestors
Becoming*, 2019
Four-channel video installation, 2K,
7.1 surround sound
28:00 min
Commissioned by Sharjah Art Foundation
Produced by Sharjah Art Foundation
with additional production support from
the San Francisco Museum of Modern Art

pp. 111–17
We Were Lost in Our Country, 2019
Single-channel video installation, color
35:00 min
Made in collaboration with the Ngurrara
People of the Great Sandy Desert,
Western Australia. Co-commissioned
by Sharjah Architecture Triennial and
the School of Architecture, University of
Technology Sydney

pp. 119–25
*Crimes of Solidarity /
Crimes de solidarité*, 2020
Two-channel video installation
71:00 min
Commissioned by Manifesta 13
Marseille and VIA Art Fund, with the
support of Ammodo

pp. 101–09
The Boat People, 2020
Single-channel video, 4K,
Super 16mm transferred to digital,
color, 5.1 surround sound
20:00 min
Produced by Bellas Artes Projects
and James Cohan, New York

pp. 181–89
*The Sounds of Cannons Familiar Like
Sad Refrains / Đại Bác Nghe Quen Như
Câu Dạo Buồn*, 2021
Two-channel video, 1920 × 1080 each
channel, stereo
09:41 min
Commissioned by Thyssen-Bornemisza
Art Contemporary for st_age

p. 248
A Dragon Through Clouds, 2022
57mm brass artillery shell tuned to 432hz
with hanging mobile
58 × 33 × 33 in (147.3 × 83.8 × 83.8 cm)
Private collection, New York

pp. 238–39
A Rising Moon Through The Smoke, 2022
Twelve plate bells with tenth from
bottom made of cast brass artillery shell,
remaining eleven plate bells cast
from 15 percent UXO bomb metal and
85 percent stainless steel
149 ⅝ × 118 ⅛ × 118 ⅛ in
(380 × 300 × 300 cm)

p. 249
Descendant, 2022
57mm brass shell tuned to F5 at 685.5Hz,
steel, silver, enamel paint
78 ¾ × 43 ¼ in (200 × 110 cm)
Courtesy Danielle and George Skestos,
Columbus, OH

p. 246
Flying Phoenix, 2022
57mm brass artillery shell tuned to
432 Hz, with hanging mobile
67 × 36 × 36 in (170.2 × 91.4 × 91.4 cm)
Gallancy Family Collection, New York

p. 250
Inside a Sound a Million Trembling Lives,
2022
Singing bowl pounded from 130mm brass
artillery shell tuned to note F# at 181Hz
11 ¾ × 11 ¾ × 11 ⅛ in (30 × 30 × 28 cm)

p. 243
Light As Smoke, 2022
Powder-coated metal mobile balanced
on 203mm bombshell
110 ¼ × 78 ¾ in (280 × 200 cm)
Private collection, Illinois

p. 251
Nothing Is Ever Lost, Nothing Ever Gained,
2022
Brass from artillery shells mounted on
black stainless steel
31 ½ × 31 ½ × 23 ⅝ in (80 × 80 × 60 cm)
Rennie Collection, Vancouver, Canada

pp. 236–37
Red Fiery, 2022
Powder-coated metal with three
brass plates made from bombshells
tuned to 432hz
64 × 108 in (162.6 × 274.3 cm)

pp. 240–41
Shattered Arms, 2022
Found antique Quan Yin sculpture,
brass hands cast from artillery shells
23 ⅝ × 19 ¾ × 15 ¾ in (60 × 50 × 40 cm)

p. 247
Spiral Explosion, 2022
57mm brass shell tuned to F#5 at 726Hz,
steel, silver, enamel paint
78 ¾ × 49 ¼ in (200 × 125 cm)
Courtesy Jody Howard

pp. 191–225
*The Unburied Sounds of a Troubled
Horizon*, 2022
Single-channel video installation,
4k, color, 5.1 surround sound
58:00 min
Brooklyn Museum, Gift of the
Contemporary Art Committee 2022.12

p. 253
Unexploded Resonance, 2022
M117 bomb dropped from B52
tuned to 432hz, hanger from antique
wooden architecture
70 ⅞ × 47 ¼ × 23 ⅝ in
(180 × 120 × 60 cm)

p. 244
A Sullen Moon Behind Lit Mountain Tops,
2023
Brass artillery shell tuned to #F5 at 685
Hz, stainless steel cable with rubber
mallet, pounded brass artillery shell,
brass rods, paracord
78 ¾ × 78 ¾ in (200 × 200 cm)

p. 245
Fallen Fallacy, 2023
57mm brass artillery shell tuned to F5 at
685 Hz, stainless steel cable with wooden
mallet, pounded brass artillery shell,
brass rods
80 ¾ × 39 ⅜ in (205 × 100 cm)

pp. 255–71
*Because No One Living Will Listen /
Người Sống Chẳng Ai Nghe*, 2023
Two-channel 4K video, stereo, 11:00 min

Film Credits

My Ailing Beliefs Can Cure Your Wretched Desires, 2017

Two-channel video installation, 1080p each channel, color, 5.1 surround sound, 18:51 min

Crew
Producer: Huỳnh Ngô Vân Anh
Director: Tuan Andrew Nguyen
Voice of Rhino: Wowy Nguyễn
Voice of Turtle: Nguyễn Ngọc Nam Phương
Dancer: Lê Duy Hải
Director of Photography: Andrew Yuyi Truong
Production Manager: Thọ Phan
Production Design: Khim Đặng
Drone and Follow Focus: Trung Lê
Consultant: Nguyễn Thị Mai Hương
Music: NVN
Sound Design, Mix, and Color: Trần Mạnh Hoàng

Special thanks: Yến Võ; Cat Tien National Park, Save Vietnam's Wildlife, Vietnam Forest Museum, Vietnam National Museum of Nature, Museum of Biology (Hanoi University of Science); and all the volunteers, interns, and workers who helped realize the creation of *Empty Forest*

—

The Island, 2017

Single-channel video, 2048 × 1080p, color, 5.1 surround sound, 42:00 min

Crew
Producer: Tuan Andrew Nguyen
Coproduced by the Burger Collection, Colección Dieresis, and Otherworld Post

Production Manager: Huỳnh Ngô Vân Anh
Cinematographer: Huy Trần
Camera/Gimbal Operator: Trung Lê
Camera Assistant: Dương Hoàng Long
Location Sound: Trương Cao Nhật Hà
Set and Props: Khim Đặng
Music: Trịnh Công Sơn and Boule Nguyễn
Vocals: Khánh Ly, Trịnh Vĩnh Trinh
Production Assistant: Mai Trọng Hiển
Sound Mix and Colorist: Trần Mạnh Hoàng, Otherworld Post
Translation and Subtitles: Tuan Andrew Nguyen, Huỳnh Ngô Vân Anh, Võ Thị Hải Yến

Cast
Phạm Anh Khoa
Donika Do Tinh

Special thanks: Ysa Le, Yvonne Tran, Binh Danh, Ed Bradley, Haji Che Muhammad Azmi bin Ngah, Hayati Mokhtar, Yee I-Lann, all those who have shared their Bidong experiences, and all former refugees who passed through Pulau Bidong

—

The Specter of Ancestors Becoming, 2019

Four-channel video installation, 2K, 7.1 surround sound, 28:00 min
Commissioned by Sharjah Art Foundation. Produced by Sharjah Art Foundation with additional production support from the San Francisco Museum of Modern Art

Crew
Written by: Anne-Marie Niane (INT. APARTMENT, SAIGON – NIGHT), Macodou Ndiaye (INT. OFFICE, DAKAR – DAY), Merry Bèye Diouf

(EXT. COURTYARD, DAKAR – DAY);
Tuan Andrew Nguyen; Jane Pujols
Producer and Director: Tuan Andrew
 Nguyen
Cinematographer: Andrew Yuyi Truong
First Assistant Camera: Allison Nakamura
Research/Coordinator: Jane Pujols
Production Support: RAW Material
 Company, Dakar; Koyo Kouoh; Marie-
 Hélène Pereira; Tabara Korka Ndiaye;
 Dulcie Abrahams Altass; Devin Hentz;
 Coralie Njikam; Mame Farma Fall;
 Aysatu Ndey Ayda Joòb; Marie Cissé;
 Ana Karima Wane; Eva Barois De
 Caevel; Lily Bayoumy; Marie Thiva
 Tran; Marie Lou Do Van; Jean-Claude
 Do Van
Fixer: Souleymane Dia
Editing: Tuan Andrew Nguyen
Color: Andrew Yuyi Truong
Sound Design and Mixing: WallSound,
 Vick Vo Hoang, Sebastian Pérez
 Bastidas
Music: "Keeping Hope" by Noreyni Seck;
 "Call to Arms for the South Vietnamese
 Army" sung by Jean Gomis Kora,
 recorded by Nomoucounda Cissoko
 at Karantaba Records, Dakar, Senegal
Research and Support: RAW Material
 Company, Idrissou Mora-Kpai,
 Laurence Gavron, Nelcya Delanoë,
 Eric Deroo, Armelle Mabon

Commissioned by: Sharjah Art Foundation
Produced by: Sharjah Art Foundation with
 additional production support from
 San Francisco Museum of Modern Art
Production Management: Vanna Huynh,
 TANQ Studios

Cast [in order of appearance]
Macodou Ndiaye, Anne-Marie Niane,
Carmen Barry, Ibrahima M.F. Ndiaye,
General Jean Gomis, Assane Bèye,
Mohamed Moreau, Ndiaye Family, Madia
Ndiaye, Béatrice Sidibé, Merry Bèye Diouf,
Lily Bayoumy, Arame Bèye, Bèye Family,
Thèrèse Moreau, Marie Thiva Tran,
Besse Diagne, Mohammad Tijani Diouf,

Jean-Claude Do Van, Ndeye Fatou Guèye,
Noreyni Seck, Bouba Diallo, Ibrahima
Sidibé, Jean-Pierre Diara, Oumou Lila
Bayo, Ibrahima I Ndiaye, Đỗ Thị Gái Diara,
Ismael Diara, Sidibé/Da Cruz Family,
Danh Thị Muội Da Cruz, Aboubacar Sy
[Bouba Chinois], Omar Wade, Bayoumy
Family, Diara Family

Extras
Bayoumy Family, Da Cruz/Sidibé Family,
Jean-Claude Do, Diara Family, Ndeye,
Fatou Guèye, Oumou Lila Bayo, Ibrahima
I. Ndiaye, Ndiaye Family, Marie Thiva Tran,
Omar Wade

Archive Footage from ECPAD:
Etablissement de Communication
et de Production Audiovisuelle de la
Défense, ACT 2345 ©Director unknown/
ECPAD/1950, ACT 2664 ©Director
unknown/ECPAD/1954, 14.18 B 315
©Henri DESFONTAINES/ECPAD/1918,
AA 512 ©Director unknown/ECPAD/1940,
ACT 2697 ©Director unknown/
ECPAD/1954, ACT 2676 ©Director
unknown/ECPAD/1954, ACT 2729
©Director unknown/ECPAD/1955, ACT
2731 ©Director unknown/ECPAD/1955,
ACT 2740 ©Director unknown/
ECPAD/1954, SCA 127 ©Director
unknown/ECPAD/1957, MAG 221
©Director unknown/ECPAD/1946, ACT
2654 ©Director unknown/ECPAD/1954,
ACT 2282 ©Director unknown/
ECPAD/1949, ACT 2350 ©Director
unknown/ECPAD/1951, ACT 2614
©Director unknown/ECPAD/1954, ACT
1135 ©Director unknown/ECPAD/1945,
FT 428 ©Director unknown/ECPAD/1942

Special thanks: Zoe Butt, Eungie Joo,
Yves Abibou, Professor Mamadou Koné
and the Military Museum Dakar, Berlin
Humboldt Universität Lautarchiv, Khim
Dang, Vo Chau Hoang Vy, Doudou
Diene, Edmond and Cambodge Bar,
Fred Hirschy, Trần Hải Anh, Mat Troi
Day, Mame Woury, Bùi Huỳnh Tuấn Anh,

Hồ Hoàng Phương Uyên, Lê Thiên Bảo, Lương Nguyễn Liêm Bình, Nguyễn Thị Vương, Phạm Minh Khánh Duy, Trần Lan Anh, Trần Ngọc Duyên, Sissoko Cheikh

—

The Boat People, 2020

Single-channel video, 4k, Super 16mm transferred to digital, color, 5.1 surround sound, 20:00 min. Produced by Bellas Artes Projects and James Cohan, New York

Crew
Director: Tuan Andrew Nguyen
Written by: Tuan Andrew Nguyen, Jane Pujols, Christopher Myers
Cinematographer: Andrew Yuyi Truong
Production Manager and Assistant Director: RJ Camacho
First Assistant Camera: Rhon Jacob Bacal
Coordinator and Research: Jane Pujols
Production Assistance: Bellas Artes Projects Team, Rj Camacho, Johannes Balagso, Ansperniel Aquino, Joanna Vocalan, Fatima Manalili, Ruby Weatherall, Tenie Santos
Edited by: Tuan Andrew Nguyen
Color: Gabe Sanchez
Sound Design and Mix: Vick Hoang, Wallsound
Music: Dewa Alit Gamelan Salukat and Itanong Mo Sa Mga Bata, composed by Asin, performed by Jam Acuzar

Artisans
Woodcarvers and Metalworkers:
Las Casas Filipinas de Acuzar Artisans, New San Jose Builders Inc., Arnold Flores (Buboy), Joseph De Ramos (Jojo), Cesar Fadul, Cesar Fadul Jr., Jerry Fadul, Zyrus Fadul, Rafael Amante, Edmar Buce Jr., Ricardo Maso, Ping Ceriola, Gerry Ortiz, Toby Fabon, Allan Cenita, Leo Albunag, Albert Fadul, Katlene Insegne, Don Quitalig, Rodmark Fontanilla

Boat Model Makers: Darrel Recana, JR Miralles
Lighting and Grip: RSVP Film Equipment Rental, Jaydie Malonzo, Reymar Itang, Edelson Bautista, Mark Anthony Rimada, Rubie Cuyog

Cast
Riana/Last Woman on Earth: Gryshyll Reyes Ilarina
Statue Head: Jam Acuzar
Boys: Michael Mendoza Soronio, John Carlos Cruz Moris, Jescee Dheivid Taba Recinte, Benedict Recinte Revelo

Special thanks: Bellas Artes Projects, Jam Acuzar, the Acuzar family, Las Casas Filipinas de Acuzar, Diana Campbell Bettancourt, Inti Guerrero, James Cohan, New York, Paula Naughton, Kaye Aboitiz, Isabelle Tee, Morong Philippines Refugee Processing Centre, Vivencio B. Dizon, Daisy R. Fernando, Mount Samat Site and Museum, BGen. Restituto L. Aguilar, NAPOCOR Village, Gerry Q. Rejano, Philippines Coastguard, Imelda Moris, Laulyn Ilarina, Bernadette Taba, Alicia Revelo, Lovely Soronio, Jocelyn Recinte, Huynh Ngo Van Anh, Aiyana Thu Linh Nguyen

—

The Sounds of Cannons Familiar Like Sad Refrains, 2021

Two-channel video, 1920 x 1080 each channel, stereo, 09:41 min

Crew
Director: Tuan Andrew Nguyen
Bomb Team: Lê Văn Minh, Trần Bình Phương, Tạ Quang Hùng, Nguyễn Đình Điệp, and the entire MAG Vietnam team, with coordination by Nguyễn Thị Trang Nhung
Production Manager: Nguyễn Xuân Phương

Camera: Dương Hoàng Long and
 Tuan Andrew Nguyen
Flycam: Nguyễn Thái Huy Vũ and
 Võ Chí Thạnh
Assistant Camera: Hà Văn Huy
Edited by: Tuan Andrew Nguyen
Postproduction Audio: Nam Nguyen,
 Vick Vo Hoang, and Wallsound
Music: Written by Trịnh Công Sơn,
 performed by Khánh Ly

Commissioned by Thyssen-Bornemisza
 Art Contemporary for st_age
Archival Footage: U.S. National Archives
 and Records Administration, Library
 of Congress
Made in collaboration with The Propeller
 Group

—

*The Unburied Sounds of a Troubled
Horizon*, 2022

Single-channel video installation,
4k, color, 5.1 surround sound, 58:00
min. Brooklyn Museum, Gift of the
Contemporary Art Committee 2022.12

Crew
Produced by: James Cohan, New York,
 Chong Chóng Films
Directed, Written, Edited by: Tuan Andrew
 Nguyen
Cinematographer: Andrew Yuyi Truong
Script and Language: Lê Nghĩa
Casting: Trương Thương Huyền
Production Manager and Assistant
 Director: Lê Nghĩa
Location Manager: Nguyễn Hoàng
 Phương, Nguyễn Xuân Phương
Focus Puller: Cồ Huy Sáng
Camera Team Leader: Huy Go
Camera Assistants: Phan Văn Xuân,
 Nguyễn Hoàng Tuấn
Set and Props: Khim Đặng, Nguyễn
 Xuân Phương
Gaffer: Hồ Hoàng Hải

Lighting and Grip: Nguyễn Hoàng Anh,
 Nguyễn Hoàng Văn, Nguyễn Văn Linh,
 Võ Sỹ Hùng
Location Sound: Ngô Quốc Kiên
Production Assistants: Trần Thanh Phước,
 Nguyễn Hoàng Phương
Travel Coordination: Huỳnh Ngô Vân Anh
Wardrobe: Thuận Từ, Minh Anh
Drivers: Nguyễn Tấn Tài, Hồ Thị Tường
 Vy, Nguyễn Văn Thắng
Colorist: Sam Gilling
Sound Mixer: Vick Vo Hoang, Wallsound
Music: "Một Ngày Như Mọi Ngày" by
 Trịnh Công Sơn, performed by Khánh
 Ly; "Hẹn Về Quảng Trị" by Nguyễn
 Tất Tùng, performed by Hồ Văn Lai
Original Music: An Bình Tất
Subtitles and Translation: Lê Nghĩa

Cast
Nguyệt: Nguyễn Kim Oanh
Mẹ | Mother: Trương Thương Huyền
Hồ Văn Lai: Hồ Văn Lai
Bà Cụ Bán Bom | Widow: Hồ Thị Kim Quý
O Mai | Aunt Mai: Hoàng Thị Thu Hồng
Cậu Bảy | Uncle Seven: Hoàng Lương
 Tâm
Nha Su | The Monk: Lê Anh Đức
Người chồng mua phế liệu | Scrap Buying
 Husband: Nguyễn Hoàng Phương
Người vợ mua phế liệu | Scrap Buying
 Wife: Lê Vân

Extras
Cô Giáo | Teacher: Nguyễn Thị Tâm
Học sinh | School Children: Bé Phương
 Anh, Bé Miu, Bé Mai Phương Linh,
 Bé Lê Thị Quỳnh Giang, Bé Nguyễn
 Thị Yến Nhi, Bé Mai Phương Thảo,
 Bé Quách Ngọc Tuấn Kiệt, Bé Minh
 Khang, Bé Huỳnh Đức, Bé Hoàng
 Quân, Bé Quốc Bảo, Bé Minh Phú,
 Bé Minh Đức, Bé Bùi Bảo Nam

Special thanks: Chính quyền các cấp
tỉnh Quảng Trị | Authorities in Quảng Trị,
Ban quản lý di tích Cầu Hiền Lương | Hien
Luong Bridge Management, Ban quản
lý di tích Giếng cổ Gio Linh | Ancient Wells
of Gio Linh Management, PS Vietnam,
Khách Sạn Golden Quảng Trị | Golden
Hotel Quảng Trị, Dự Án Renew | Project
Renew, Chùa Linh Hải, Huyện Gio Linh,
Quảng Trị | Linh Hải temple, Thầy Thích
Nhất Hạnh, Nguyễn Thanh Phú, Lê Văn
Minh, Nguyễn Đình Điệp, Doãn Quang,
Bùi An Phúc, Cafe Cũ 1972, B's Cafe,
Huỳnh Ngô Vân Anh, Ayana Thư Linh
Nguyễn, Talan Anh Nguyễn

—

*Người Sống Chẳng Ai Nghe / Because
No One Living Will Listen*

Two-channel 4K video, stereo, 11:00 min

Crew
Produced by: James Cohan, New York,
 Chong Chóng Films, Specter Studios,
 and The Vega Foundation
Directed and Edited by: Tuan Andrew
 Nguyen
Written by: Nguyễn Thị Xuân (a.k.a.
 Habiba Mohammed Benaissa),
 Tuan Andrew Nguyen, Lê Nghĩa
Cinematographer: Dương Hoàng Long
Assistant Director: Lê Nghĩa
Research and Production Management:
 Lê Nghĩa, Tài Thy
Post-production Producer: Khang
 Brutality, Thư Võ
Post Supervisor: Lê Hữu Phước
CGI Artist: Lê Minh Thuận
VFX Artist: Phạm Thành Trung
Online Artists: Nguyễn Vũ Thiện , Lý Hoàn
 Anh, Nguyễn Hoàng Duy, Hà Phú Minh
 Nghĩa
Sound Designer: Vick Võ Hoàng

Cast
Nguyễn Thị Xuân (a.k.a. Habiba
Mohammed Benaissa)

About the Artist

Tuan Andrew Nguyen (b. 1976, Saigon, Vietnam) lives and works in Ho Chi Minh City. In 1979, he and his family emigrated to the United States as refugees. Nguyen received his BA from the University of California, Irvine, and MFA from California Institute of the Arts. Nguyen is a founding member of The Propeller Group, which has received the main prize at the 2015 Internationale Kurzfilmtage Winterthur and a Creative Capital Award. Nguyen's work has been the subject of solo exhibitions at the Centre for Contemporary Arts, Glasgow, UK, and Marabouparken Konsthall, Stockholm (both 2023). His videos and films have been included in major international festivals, biennials, and exhibitions, including the 12th Berlin Biennial; Manifesta 14, Prishtina, Kosovo; Aichi Triennial, Japan; Dakar Biennial, Senegal (all 2022); Asian Art Biennial, National Taiwan Museum of Fine Arts, Taipei (2021); Manifesta 13, Marseille, France (2020); Sharjah Architecture Triennial, UAE; "SOFT POWER," San Francisco Museum of Modern Art; Sharjah Biennial, UAE (all 2019); Whitney Biennial, New York (2017); 55th International Short Film Festival, Oberhausen, Germany (2009); 8th NHK Asian Film Festival, Tokyo (2007); 18th Singapore International Film Festival (2005); and 4th Bangkok Experimental Film Festival (2005). Nguyen is the recipient of the 2023 Joan Miró Prize.

Board of Trustees

Photography Credits

Unless otherwise noted, all images are courtesy the artist and James Cohan, New York © Tuan Andrew Nguyen

Except:

p. 13: Photo: Benoit Pailley

p. 60: Courtesy Smoking Dog Films and Lisson Gallery

pp. 82–83: Finnish National Gallery (FNG) / Petri Virtanen

pp. 94–95: Courtesy the Whitney Museum of American Art. Photo: Ronald Amstutz

pp. 112–13, 226, 227, 230–31, 232–33: Photo: Tuan Andrew Nguyen

pp. 120–21, 122–23: Photo © 2023 Jeanchristophe Lett, Manifesta 13 Marseille. Commissioned by Manifesta 13 Marseille and VIA Art Fund, with the support of Ammodo

pp. 130–31: Courtesy the Berlin Biennale. Photo: Laura Fiorio

pp. 132–33: Courtesy of Sharjah Art Foundation. Photo: Shanavas Jamaluddin

pp. 164–65: Bundesarchiv, Bild 146-1999-002-00

pp. 167, 169: © 2023 Merry Beye Diouf

pp. 170–71, 179 top: © 2023 Jean Claude Dô Van

p. 173: © 2023 Ousseynou Faye

p. 175: © 2023 Sophie Diagne

p. 176: © 2023 Pape Charles Seck

pp. 177, 179 bottom: © 2023 Marie Nguyen Thiva Tran

p. 178: © 2023 Carmen Leissa Barry Family Photographic Archives, Medina

pp. 182–83: Commisioned by Thyssen-Bornemisza Art Contemporary for st_age. Photo: © 2023 Manifesta 14 Prishtina / Majlinda Hoxha

pp. 192–93, 238, 239, 248: Photo: Phoebe d'Heurle

pp. 236–37, 250: Photo: Dan Bradica

pp. 240, 241, 253: Photo: Culacstudio

pp. 243, 246, 247, 249: Photo: Izzy Leung

pp. 244, 245: Courtesy Marabouparken Konsthall, Stockholm.
Photo: Jean Baptiste Béranger

Published by
New Museum
235 Bowery
New York, NY 10002

On the occasion of the exhibition
"Tuan Andrew Nguyen:
Radiant Remembrance"
June 29–September 17, 2023

© 2023 New Museum, New York

Curator: Vivian Crockett
Curatorial Assistant: Ian Wallace

Contributions by:
Zoe Butt
Vivian Crockett
Catherine Quan Damman
Eungie Joo
Christopher Myers
Nghiêm Phái-Thư Linh

Copy Editor: Sarah Stephenson
Design Template: An Art Service
Design Production: Nicholas Weltyk
Printing: SPC, Poland

"Tôi Về (I Return)" by Nghiêm Phái-Thư
Linh Translators: Lê Nghiêm Minh Trí,
Tuan Andrew Nguyen, and Tài Thy

Front Cover: *The Specter of Ancestors
Becoming*, 2019 (still). Four-channel video
installation, 2K, 7.1 surround sound,
28:00 min. Commissioned by Sharjah
Art Foundation. Produced by Sharjah Art
Foundation with additional production
support from the San Francisco Museum
of Modern Art

Back Cover: *The Unburied Sounds of a
Troubled Horizon*, 2022 (still). Single-
channel video installation, 4K, color, 5.1
surround sound, 60:00 min

NEW MUSEUM

ISBN: 978-0-915557-30-1

Support for this exhibition is provided by
the Toby Devan Lewis Emerging Artists
Exhibitions Fund.

Artist commissions are generously
supported by the Neeson / Edlis Artist
Commissions Fund.

Generous support is provided by
The Vega Foundation.

We gratefully acknowledge the
International Leadership Council of the
New Museum.

Thanks to James Cohan, New York.

Education and community programs are
supported, in part, by the American Chai
Trust.

Support for the publication has been
provided by the Carl & Marilynn Thoma
Foundation and the J. McSweeney
and G. Mills Publications Fund at the New
Museum.

thoma
FOUNDATION